(Grid<>Matrix)

Sabine Eckmann
Lutz Koepnick

With contributions by
Gwyneth Cliver
Patience Graybill

SCREEN ARTS AND NEW MEDIA AESTHETICS / 1

Mildred Lane Kemper Art Museum / Washington University in St. Louis

This volume is published in conjunction with the exhibition [Grid < > Matrix], the first in the *Screen Arts and New Media Aesthetics* series organized by the Mildred Lane Kemper Art Museum at Washington University in St. Louis. The exhibition was held from October 25 through December 31, 2006.

Support for this project was provided by the Hortense Lewin Art Fund and individual contributors to the Mildred Lane Kemper Art Museum.

Published by
Mildred Lane Kemper Art Museum
Sam Fox School of Design & Visual Arts
Washington University in St. Louis
One Brookings Drive
St. Louis, Missouri 63130

Editor: Jane E. Neidhardt, St. Louis
Editorial assistant: Eileen G'Sell, St. Louis
Designer: Michael Worthington & Yasmin Khan,
Counterspace, Los Angeles
Printer: Transcontinental Litho Acme, Montréal

Library of Congress Control Number: 2006934243
ISBN: 0-936316-20-9

MILDRED LANE KEMPER ART MUSEUM
WASHINGTON UNIVERSITY IN ST. LOUIS

Cover: Dan Flavin, *Untitled (in honor of Leo at the 30th anniversary of his gallery)*, 1987. Courtesy of the Panza Collection, gift to Fondo per l'Ambiente Italiano, 1996, on permanent loan to the Solomon R. Guggenheim Foundation, New York, L195.93. Photograph by David Heald © The Solomon R. Guggenheim Foundation, New York. © 2006 Stephen Flavin / Artists Rights Society (ARS), New York.

Back cover: Julius Popp, *Bit.Fall*, 2006. Courtesy of Galeries Jocelyn Wolff, Paris & Nächst St. Stephan, Vienna. Photo by François Doury.

CONTENTS

Acknowledgments

The 2006 inauguration of the Mildred Lane Kemper Art Museum building calls for exhibition programs that explore contemporary art and its relationship to new technologies. Although new media arts have garnered much attention by the critical public, it is still challenging to exhibit such art in museums and make it available to larger audiences. Due to the often time-based nature of this work and its technological demands, it resists easy storage, not to mention canonization, which makes it difficult for curators to draw on existing archives, collections, and institutions to organize exhibitions. Because much of this work is experimental and pushes the possibilities of advanced technologies, aesthetic standards for new media art are still developing. The *Screen Arts and New Media Aesthetics* series is designed to initiate discourse about the aesthetic specificity of new media art. It is motivated by the hope of transforming the Museum into a location for engaging with art's future today.

[Grid < > Matrix], the first installment in the *Screen Arts and New Media Aesthetics* series, would not have been possible without the generous support of the Sam Fox School of Design & Visual Arts, in particular Dean Carmon Colangelo and his unwavering commitment to new exhibition programs; the College of Arts & Sciences, which continues to enable some of the Museum's most meaningful collaborations; the Hortense Lewin Art Fund of Washington University, which provides essential funds for exhibitions, publications, and related programs; and the foundational support of individual donors to the Museum.

Within the Kemper Art Museum special thanks go to Jane Neidhardt, managing editor of publications, for her meticulous editorial support; Eileen G'Sell for her editorial assistance; and Michael Worthington for his astute design of this catalog. We want to express particular gratitude to Associate Registrar Rachel Keith for her indefatigable energy in organizing loans while helping to navigate us through the unknowns that come with the opening of a new museum; to Jan Hessel, facilities manager and head art preparator, and her exceptional team, without whom none of these plans would have been realized; and to the rest of the Museum staff, all of whom have gone beyond the normal bounds of dedication to make this project and the new museum possible.

Additional thanks go to exhibition architects HKW Architects, under the creative and calm leadership of Kevin Kerwin, and to our colleagues at the Saint Louis Art Museum, who continue to share the common pursuit of excellence in the arts, including their expertise as well as the loan of artworks. Special thanks there go to Conservator Paul Haner, Curator Cara McCarty, and Curator Andrew Walker, as well as to Director Brent Benjamin for his genuine interest in collaboration. We would also like to thank contributing authors Gwyneth Cliver and Patience Graybill, whose participation in the project was both a pleasure and an asset. And finally, thanks go the individuals and organizations who lent to the exhibition. Their trust and generosity made it possible.

Sabine Eckmann
Director and Chief Curator
Mildred Lane Kemper Art Museum
Sam Fox School of Design & Visual Arts
Washington University in St. Louis

Lutz Koepnick
Professor of German, Film and Media Studies
College of Arts & Sciences
Washington University in St. Louis

Introduction

Electronic screens are ubiquitous today. Whether stationary or mobile, they serve as interfaces connecting public and private spaces, the local and the global, the present and the past. Whether digital or analog, screens dominate our perception of reality, structure our understanding of identity and ideology, and shape our daily practices of communication, self-expression, and consumption. A series of exhibitions presented over the course of several years, *Screen Arts and New Media Aesthetics* explores the interpenetration of different screens of representation in contemporary culture— from the canvas to the computer terminal, the cinema to the television set, the video monitor to the museum wall, the book page to the cell phone display. The exhibitions in this series probe the aesthetic uses and historical dimensions of contemporary screen culture. They shed light on how different artists make use of newer media and technologies, how the rise of the digital impacts dominant codes of art, culture, and experience, and how today's screens open alternate windows on the past, present, and future.

[Grid< >Matrix] is the first exhibition in this series. It traces two different but closely related modes of organizing the visible world and its aesthetic representations. In analog cultures, the notion of the grid empowers the production of images that claim universal authority. Most often static in nature, grid-like structures, spaces, and images approach the viewer as immediately recognizable and hence devoid of unwanted surprises. Digitally-based matrices, by way of contrast, set the modernist grid into motion. They have the ability to catalyze visual expressions and experiences that, in spite of their algorithmic foundations, aim at open-ended and often unpredictable transformation. Grid and matrix, as presented in this exhibition, form a central dialectic of modernist and postmodernist culture. The exhibition's aim is not to tell a story of linear historical progress, but to explore continuities and ruptures between the analog and the digital, between the organizational principles of older and newer media.

Modern urban planning and industrial production processes are unthinkable without the relational structure of the grid. Arranging individual elements within uniform patterns of perpendicular lines, the grid helped shape modern cities and industrial factories into calculable mechanisms of serial production, transportation, exchange, and inhabitation. In the realms of painting, film, and installation art, the grid enabled art's capacity to distance itself from language, figuration, and representation and provided visual experiences favoring simultaneity over the sequential, the spatial over the temporal, the abstract over the representational, and the universal over the particular. Modern artists embraced the grid as a tool, at once stressing art's inevitable relationship to technological progress and warranting the purity, or autonomy, of the image. Theo van Doesburg and Piet Mondrian employed the grid as an immaterial structure able to engineer the construction of a new world, one which would energetically reflect the possibilities of technological innovation. By contrast, in the works of postmodern artists such as Dan Flavin and Andy Warhol, the grid appears as an aesthetic form that allows industrial mass culture to interpenetrate the hermetic sphere of high art and reshape the role of the aesthetic in society.

The grid, of course, plays an important role in today's culture of omnipresent computing as well. Digital photography, for instance, subdivides images into grids of discrete pixels, each of which can then be manipulated according to a certain range of integers. But it is the notion of the matrix that has come to denote the underlying structures of digital culture in much more emblematic ways. In mathematics, matrices are understood as rectangular arrays of data used to display certain functions. As a reworking of the grid and its legacy, the matrix doesn't simply map, structure, or contain relationships, but engenders them in the first place. Matrices emancipate the grid from its confinement to two dimensions; they displace the grid's tendency toward the static and unchangeable. In the well-known films of the Wachowski Brothers, matrices are places from which something else might originate. They extend into time, they display data and codes as three-dimensional phenomena, and they envelop our senses with virtualizations of the real.

[Grid< >Matrix] gathers a number of digital artworks that draw our attention to the matrix's dialectic of the immaterial and the embodied, the invisible and the phenomenal. Whereas the flatness of the grid tends to organize vision and aesthetic experience within self-contained and predictable structures, matrix art seeks to rediscover a sense of temporal openness and malleability, of narrativity and language, of the unpredictable and the aleatory. Albert Oehlen, for example, combines patterns generated by the matrix with subjective painterly gestures in order to probe the affinities between digital technology and abstract painting. Andreas Gursky fuses

the grids of modern book culture and the resources of digital technology to offer an intricate matrix of visual intensities and unpredictable effects. Jeffrey Shaw creates interactive virtual environments that produce changing images of gridded cities made of words, drawing upon the history and local specificities of individual cities while acknowledging their surreal and simulated character. And Julius Popp transmits words selected by the frequency of their use in Internet news sites via the ephemeral medium of water: an enormous water wall briefly visualizes the words before they disappear.

Screen Arts and New Media Aesthetics is designed to stimulate discussion about the aesthetics of the digital and the location of new media art in current research, discourse, and artistic practice. Although publications and exhibitions on new media are wide-ranging and include monographic studies, historical accounts, and theoretical analyses, thematic explorations that connect theoretical discourse with aesthetic forms are still rare. The aim of this series is to provide such a platform. It will place electronic art forms side by side with older forms of technological art, such as photography, film, and video, to advance our understanding of how electronic windows, screens, and interfaces today structure aesthetic experience and practice.

SE, LK

Given:
An Icon described
by a 32 X 32 Grid

Allowed:
Any element of the
grid to be colored
black or white.

Shown:
Every Icon

Owner:
John F. Simon, Jr.

Edition Number:
Artist's Proof

Starting Time:
January 14, 1997, 9:00:00 pm

www.numeral.com

Grid *(grid) n.* 1. a grating of parallel bars; gridiron. 2. a network of horizontal and perpendicular lines, uniformly spaced, for locating points on a map, chart, building plan, or aerial photograph by means of a system of coordinates. 3. any interconnecting network resembling this.[1]

1. Definitions of the term "grid" appearing here are adapted from the *Oxford English Dictionary Online*, http://www.oed.com (cited July 17, 2006).

An enduring presence in cultural and social productions since ancient times, the grid has taken on many manifestations and social functions. Whether as blueprints for settlements, frameworks supporting buildings, or sketches on canvas, grids have long served to order social constructions. The abstraction of the grid as a stabilizing and organizing concept has facilitated new relationships to space and time; humans apply the grid's ordering principles to tame, manipulate, and develop them. As the grid has empowered our ability to build edifices—both real and virtual—its static presence has penetrated every aspect of our social and cultural existence. It directs the very make-up of everyday reality as well as our perception of that reality.

From the Ancient World to the Renaissance: Grids as Tools of the Trades

The grid has long been an instrument of daily industry, functioning mainly as a structuring or supporting device. Its presence in artistic and social constructions, however, often remains largely invisible.

The word "grid" derives from "gridiron," a lattice of parallel metal bars used in various capacities. Gridirons were once cooking utensils, used for broiling flesh over a fire, or as instruments of torture. Gridirons also served and continue to serve as structural frameworks in the technical domain, such as in the nautical, theatrical, and architectural fields.

2. See Dan Cameron, "Living Inside the Grid," in *Living Inside the Grid*, exh. cat. (New York: New Museum of Contemporary Art, 2003), 11–48.

3. Ibid., 15.

In addition to functioning as the layout for new settlements, such as Roman forts and the city of Peking, grids helped chart aesthetic fields throughout the ancient period.[2] Egyptians, for example, used grids to control the proportions of their sculptures and paintings.

During Western Europe's Renaissance period, grids provided a means to distribute figures across the canvas and achieve realistic perspectives. Florentine painters in the fifteenth century used single points on a grid to create imaginary distances from which all other spatial representations derived. Art historian Dan Cameron attributes Renaissance perspectivism with fundamentally changing the work of art's relationship to space.[3] Applying the grid to canvas enabled the development of the realistic, illusionist conventions that would come to dominate Western art.

From the Enlightenment to High Modernism: The Grid as Modern Ideal

The Cartesian map—one might call it the empiricist's grid—represents the Enlightenment's confidence in human reason. Rene Descartes' system, developed in the seventeenth century, uses coordinates to locate unique points along an X/Y plane. It serves as the basis for modern analytic geometry, calculus, and cartography. Cartesian coordinates not only allow the mapping of abstract space, they also inform geometric models and other practical modes of spatial distribution. The Cartesian map embodies the notion that humans can manipulate abstract mathematical laws in order to create new, concrete realities. Its importance coincided with the rise of modern science and the empirical study of natural laws. The outcome of this charting system was a self-appointed authority over uncharted space. Imposing grids onto space, therefore, became a means to control, discipline, and take possession of it; uncharted space became "uncultivated" territory, waiting to be colonized and "civilized" by modern man.

With the onset of industrialization and rapid urbanization, mapping space became a necessity. Grids aid in the design of mechanical parts and industrial networks. They also provide a rational, stabilizing principle amidst increasingly complex social structures. From urban planning to architecture, from industrial engineering to bureaucratic systems, modern infrastructures mimic the grid. The rise of the electrical power grid, for example, marks the spread of technology and, consequently, the modernization of general society.

In the early twentieth century, grids emerged from the background of the canvas to become the subject of art. For artists, the grid became

a symbol of modernity itself—an emblem of rationalized, industrial society and of new modes of representation. The grid denoted a simple, or "pure," abstract language, one that would open the way to new visual experiences. But theirs was also a self-conscious exploration into the creative process. To place the grid on canvas was to return to the moment of genesis, to human reason and originality as the source of all culture. As art historian Rosalind Krauss has argued, the modernist grid became a mythical symbol of the artist's transcendent creative powers.[4]

4. Rosalind E. Krauss, "The Originality of the Avant-Garde," in *The Originality of the Avant-Garde and Other Modernist Myths* (Cambridge, MA: MIT Press, 1985), 151–70, esp. 159.

Early twentieth-century artists also used the grid to address the mechanization of society. Their representations reminded viewers that grid-like models help standardize industrial production and streamline social infrastructures. Art of this time betrays a fear that normalized production models might also pressure human beings to fit standard molds. Thus, although the modernists' grid expresses a faith in humanity's ability to order and create the world, it also generates an anxiety about the potential of rational constructions to alienate individuals from their individuality.

Postmodernity and the Computer Age

With the arrival of computers and information technologies, industrialized societies achieved an extreme level of rationalization and technocratization. The proliferation of computer technology and data systems has transformed modern society into one of rapid data exchange and digital culture. So-called "computer grids" connect users across distances, making it possible to share (or steal) data on a parallel system. In the digital visual culture industry, grids inform graphic and webpage design. Digital technology controls analog images by attaching them to a virtual grid. Layers of grids are used to create multi-dimensional digital images. "Grids," therefore, imply both the worldwide network connecting computer terminals and the logic systems used to program them.

In contemporary art and thought, one finds a sense that the grid is all-pervasive. The question whether grids serve humans, offering tools of endless stabilizing and constructive potential, or alienate people, controlling and limiting their everyday perceptions, remains a productive debate for artists and thinkers today.

Patience Graybill

left
Carsten Nicolai
modular re.strukt (detail), 2003

(Grid<>Matrix): Take I

Over the course of the twentieth century, two developments radically altered the meaning and methods of rendering visible imaginary as well as material worlds: the invention of photography and film, and the separation of art production from political and social functions. One by-product of this modernization was the aesthetic liberation of artistic practices from the traditional constraints of mimetic representation and narration; an engagement with new forms of visibility emerged, forms that often rely on pure visuality. These new images, frequently abstract in nature, redefine relationships between art and the "real" and negotiate fresh ties between representation and mediation, simulation and imitation, illusion and imagination, and between the visible and invisible.

One model that is frequently understood to embody pure visuality is that of the grid. Beginning early in the twentieth century the grid advanced as a significant form in the visual arts, occupying artists as a measured structure devoid of randomness, geometrically ordered yet, within the parameters of its lattice, infinitely variable and thus always the same but never complete. Its order is predominantly one of repetition that ideally manifests in an all-over pictorial surface.[1]

1. Rosalind Krauss qualifies the grid as one of most successful artistic models of the past century. See Rosalind E. Krauss, "Grids," in *The Originality of the Avant-Garde and Other Modernist Myths* (Cambridge, MA: MIT Press, 1985), 8–22.

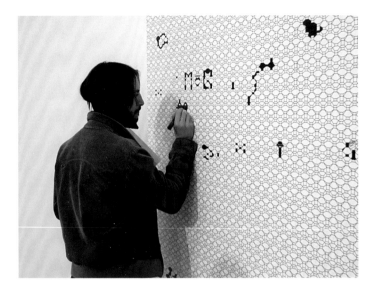

2. See ibid., 17.

Rational and stable, the grid also references our material world insofar as it informs much of modern design, from typography to urban planning to industrial production processes. Yet as much as the grid is a paradigm of modernization and technological innovation, so too did artists employ it toward opposite ends. Rather than embracing it as symbolic of the modern world, artists imbued it with hermetic and spiritual qualities, fostering the notion of the pure and autonomous image. In the hands of artists the grid granted independence from narration and contextuality and enabled progress toward absolute visuality—the much sought-after autonomy of the modern artwork.

By contrast, we may argue that the matrix is unpredictable, fluid, disparate, disjunctive, ambi- and multivalent, and, importantly, frequently invisible.[2] The digital matrix, consisting of pixilated visual bits created by a binary code of numbers, transforms the static modernist grid into a moving configuration, one that is nevertheless still informed by the basic structure of the grid. Yet, in contrast to the modernist grid, the digital matrix may remain invisible and is capable of forming images independent from its own structure. This is made evident by Carsten Nicolai with *modular re.strukt* (2003, pp. 14, 16), an interactive artwork. It consists of wallpaper mounted to a gallery wall. Its surface shows a matrix: womb-like forms in various shapes and sizes. It is the viewer's task to draw new forms on top of the matrix in order to

demonstrate its very nature, visualizations embedded in the structure of the matrix that are nevertheless independent from it.

The capability of the matrix to generate images different than itself allows artists to use digital imaging technologies and their underlying grids of mathematical codes without being confined to an abstract and rigid structure. The Warner Brothers' Matrix Code screensaver renders this readily visible: streams of numbers flow across the screen in a perpendicular grid, then transform into dynamic and three-dimensional abstract spaces that give way to rotating geometric objects which in turn meld into images of beautiful landscapes and urban sites, both past and present, that look realistic while at the same time artificially mastered. Another instance of visualizing the dialectic of grid and matrix, visible and invisible, is John Simon's *Every Icon* (1996, p. 10). On a computer screen we see a monochromatic grid divided into many small squares. As a software program explores all possible combinations of black and white squares within the form of the grid, the invisible matrix intrudes, changing the grid's visual identity by setting it into motion. Undergoing several permutations of its original form, the grid nevertheless remains one and the same while the matrix, independent from a fixed form, is shown as the tool that creates these new images.

If the analog grid liberated of mimesis and reality is visually identical with itself, the digital matrix is not only a structure that is most often invisible but also one that produces new orders of visibility, simulacra for which no originals exist. We may then understand the grid as a structure of visibility that is static and, despite its deviations, repetitive in appearance, while the digital matrix is capricious, impermanent, and incalculable, notwithstanding the fact that it too is mathematical, based on binary codes of numbers.

This essay will chart how the modernist grid has been used by artists to establish forms of pure visibility while openly acknowledging the abandonment of mimesis, narration, and the construction of the real and the ideological. Conversely, it will ask how the matrix, despite its quality as an invisible structure, constitutes the visible, establishes meaning, and reinserts into the realm of art the external world—time and space—but also illusion and fiction.

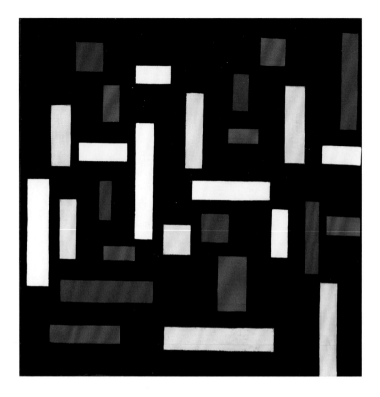

I.

As a strict ordering method the grid is abstract insofar as it does not imitate objects, people, or sites that we associate with reality. At the same time, the grid is also not abstract: it may be seen to constitute an object in itself. This new object, however, devoid of language and mimesis, signifies only itself and thus establishes a paradigmatic instance of self-referential visibility. Similarly, artists' experiments with grids are at once purely abstract and convey uses, meanings, and implications of the grid in our modern and postmodern world. The material world of modern urbanity and popular culture permeates the abstract grid in Piet Mondrian's *Composition of Red and White* (1938–42, p. 52) and Andy Warhol's *Twenty Blue Green Maos* (1979, p. 59). Synchronic time and narration, and by extent new forms of vision shaped by film and television, are tested within the geometric structuring system in László Moholy-Nagy's *Dynamic of the Metropolis* (1921–22, pp. 46, 50–51) and Robert Rauschenberg's *Coda* (1989, p. 56). And spirituality and transcendence, yet also authorship and the creation of subjective worlds, are at stake in paintings by Agnes Martin and Theo van Doesburg. The grid as an ordering structure that promises pure visibility and an

Theo van Doesburg
Composition VII: The Three Graces, 1917

autonomous realm for art is thus complicated, if not undermined, by these artists as they also invade their grids with content and discourse in order to produce new relationships between the spiritual and material world, and between artistic imagination and instances of the real.

Viewed in a dialogical relation, van Doesburg's *Composition VII: The Three Graces* (1917, p. 18) and Martin's *Untitled #2* (1995, p. 21) compellingly demonstrate that the deployment of the grid as a universal and timeless structure retained relevance throughout the last century. Precisely because the grid visualizes nothing other than itself, devoid of links to history, it offers itself as an ideal model to be infused with new meaning. As art historian Rosalind Krauss pointed out, since the very beginning of the twentieth century artists have scrutinized the grid as a structure capable of embodying "Being or Mind or Spirit" and seen it as "a staircase to the Universal."[3] The grid for such artists, rather than presenting pure vision or a rational modernity, became a tool with which to fashion new spiritual worlds.

Such an undertaking concerned both van Doesburg, the prolific Dutch constructivist who founded in 1917 the journal and art movement de Stijl,[4] and Martin, a contemporary of the Abstract Expressionists and a figure celebrated as prefiguring Minimalism. Both were throughout their careers in search of an artistic practice that would evoke spirituality and timelessness through abstract form; in other words, they endeavored to make visible the invisible. Martin's aim was to create an absolute form that would completely transcend the natural and material world and inspire spiritual contemplation and meditation. Art historian Michael Govan described Martin's "infinite vision" as conveying "a pure, abstract, egoless, untroubled state of mind."[5] Van Doesburg's concept of a new spirituality was no less utopian, yet at the same time it also acknowledged the current human condition as one of alienation. In contrast to Martin's solitary artistic pursuits characteristic of late-twentieth-century individualistic retreats from a thoroughly commodified art world, van Doesburg worked in collaboration with fellow artists, designers, and architects to create artworks—also "egoless," or depersonalized—yet based on the shared goal of building a more just and humane society.[6]

3. Ibid., 10.
4. Founding members of the de Stijl group included the painter Piet Mondrian, the sculptor Georges Vantongerloo, the architect JJP Oud, and the designer and architect Gerrit Rietveld. Interdisciplinary in its formation, this avant-garde movement intended to develop a new aesthetic consciousness as well as art and architectural forms based on rational principles. Their work embraced the fine arts, design, city and town planning, and art theory. Artists and architects collaborated in the design of houses, buildings, and furniture.
5. Michael Govan, "Agnes Martin," http://www.diacenter.org/exhibs_b/martin/essay.html (cited August 18, 2006).
6. In the words of Mondrian, "The pure plastic vision should build a new society, in the same way that in art it has built a new plasticism." As quoted in Serge Lemoine, *Mondrian and De Stijl*, trans. Charles Lynn Clark (London: Art Data, 1987), 29.

7. Theo van Doesburg,
as quoted in Carel Blotkamp,
ed., *De Stijl: The Formative
Years*, 1917–1922, trans.
Charlotte I. Loeb and Arthur
L. Loeb (Cambridge, MA:
MIT Press, 1986), 16.

Despite the quest of de Stijl artists for pure abstract forms, van Doesburg over and over again chose representational motifs which he then transformed into abstract and irregular grids, as in *Composition VII: The Three Graces*. In this work, as well as in others, van Doesburg took up the motif of three female dancers that was popular in modern art; he deemed dance "the most dynamic expression and therefore the most important subject for pure visual art."[7] Van Doesburg's dance materializes on canvas as a reasoned yet playful arrangement of rectangular color planes on a black background. In addition to the non-color white that corresponds with the black, van Doesburg reduced the color palette to the primary colors of yellow, red, and blue. The color planes repeat in size and shape in order to form a dynamic, rhythmic interplay, an

essential, universal, and de-gendered abstraction of the phenomenon
of the dance. This new, pure form of dance, its very essence, is
inscribed into the rigid form of the grid in order to make it visible.
However, the painted grid is not free from a deliberate engagement
with the medium of painting as a form of illusionism and subjective
imagination. Although the canvas is distinguished as non-
hierarchical field of vision rather than an illusionistic composition,
van Doesburg's painting retains a differentiation between the three-
dimensional canvas as support and the flat, colored forms that are
painted onto it. By preserving this divide between ground and figure,
the Dutch painter holds on to the fictional promise of painting.
Similarly, van Doesburg does not abandon mark-making and
authorship: all of his rectangles are slightly irregular and deliberately
reveal the painter's brushstrokes. The artist thus emphasizes that
this grid, a harmonious interaction between rational forms and
pure colors, brings to visibility a new spiritual world, one that is
contemporary rather than informed by historical models.

8. Govan, "Agnes Martin."

 Agnes Martin's *Untitled #2* shares with van Doesburg's canvas not
only the shape of a regular square. She too aligns colors and shapes in
such a way that they appear to float; willful composition gives way to
even and horizontal bands of color. Unlike van Doesburg's deployment
of primary colors, however, Martin uses colors—an expansive pale
blue and softened white—that in themselves evoke beauty and
transcendental realms. It is consistent that her pictorial surface
has—in contrast to van Doesburg's—a strong object-like presence, far
removed from any suggestion of painting as an illusionistic device.
Yet, in contrast to Govan's assertion that Martin's paintings display
"egoless" qualities, a dense network of marks populates her surface.
Together with the horizontal orientation of her painting that could
logically extend into infinity, imbuing her intricate and irregular
marks and pale color palette with a sense of fleeting presence, Martin's
painting-object accomplishes a visualization of the immaterial
world of the mind. Govan has compared her aesthetic manifestations
with an "emanation of light."[8] The dominant network of painterly
marks, however, that guides the aesthetic experience of her canvases
undermines the clarity, the ridgity, and rational organization of

21

9. See Krauss, "Grids."

the structure of the grid, and work towards complicating the grid as a form of pure visuality. I want to suggest that Martin's maze of marks is comparable to the quality of the digital matrix insofar as it impedes visibility through the intervention of abstract and expressive painting as to insist on the penetration of imagination and creativity into the realm of rational modernism.

II.

Rather than embracing the flat grid as new visual form of the spiritual, Piet Mondrian, in his exile artworks executed in New York between 1940 and 1944, the year of his death, used the grid to thematize the dialectic of pure visuality and the material world. Similar yet much more explicit in this respect are the grids of Andy Warhol and Dan Flavin from the second half of the twentieth century. When considered together, the work of all three constitutes an aesthetic embodiment of the grid that doubles the nature of the grid as a paradigm of modernity—the grid not only signifies modern form but also contains it. Yet as we will see these artists also use the grid to inquire how modern material culture might be visualized within the aesthetic sphere in order to deploy contingent rather than affirmative perceptual experiences.

Mondrian's *Composition of Red and White* (1938–42, p. 52), a grid of black perpendicular and parallel lines that form rectangles of various colors and shapes, belongs to a group of canvases he began in Europe and reworked once he arrived in his voluntary exile in New York. The grid itself has been qualified as exilic due its qualities of silence and anti-mimeticism.[9] Therefore it is striking that, in contrast to some of Mondrian's earlier grids, specifically those of the 1910s, he transformed the grid in exile into a structure that, despite it pure abstract qualities, reaches beyond the frame of the canvas into the context of American urbanity. He accomplishes this by deliberately presenting *Composition of Red and White* as fragment of a larger whole. It can of course be argued that the grid in itself is always a fragment and never complete, as its basic structure of horizontal and vertical lines is potentially endless. Yet Mondrian created a composition that engages the viewer with a construction of color planes and bars that demand a logical continuation beyond the actual canvas. In other works from this period

Mondrian also used common tape as well as paint in his canvases, violating concepts that understand modernist painting and above all the paradigmatic grid as modes of disembodied opticality. By including three-dimensional materials, rendering black lines as spatial layers, and focusing on the grid as part of a larger entity, Mondrian in exile probed the grid as a structure of pure art and visibility while also forcing it into the materiality of life.

We may then want to understand *Composition in Red and White* as a fragment of the rational urban grid of New York that so fascinated Mondrian. Importantly though, the painting remains ambiguous, occupying two worlds at once yet refusing to mesh them. The artist confronts the flat and geometric grid as a form of pure visuality with a manifestation of the grid as *pars pro toto*, as a representation of urban modernity actually energizing the grid with spatialization and mimesis. For Mondrian in exile in New York, the vitalizing and stimulating sensations of modern American life—jazz, traffic, the urban fabric of New York—prefigured the realization of his utopian concept of neo-plasticism, a new image which he envisioned as absolute harmony and one which would visualize the conditions of a new world.[10]

It is not farfetched to understand the works of Andy Warhol and Dan Flavin as compelling articulations of Mondrian's American project. Although neither artist embraced Mondrian's modernist utopia of a better world, they similarly challenged the grid as a form of absolute visibility by penetrating it with mass cultural objects while at the same time asserting the realm of art as one of aesthetic autonomy. Warhol's *Twenty Blue Green Maos* (1979, p. 59) shares with Mondrian's composition an expanding grid: the images of Mao could continue in any direction, and in fact in other variations of this motif Warhol indeed assembled the same image in different quantities. What is important to our discussion though is that Warhol on one hand mimics the ubiquity of images of iconic personalities of the late twentieth century through the circulation of print media, and on the other distinguishes the particular image by elevating it into the sphere of art and even inscribing it into the form of the grid. Although Warhol's silkscreen holds onto mass-media printing technologies, he alienates the image of Mao through serial repetition

10. See Matthew Affron, "New York's Impact on Modernity: Fernand Léger, Piet Mondrian," in Stephanie Barron and Sabine Eckmann, eds., *Exiles + Emigrés: The Flight of European Artists from Hitler*, exh. cat. (New York: Harry N. Abrams; Los Angeles: Los Angeles County Museum of Art, 1997), 183–94; and Harry Cooper and Ron Spronk, *Mondrian: The Trans-Atlantic Paintings*, exh. cat. (New Haven: Yale University Press; Cambridge, MA: Harvard University Art Museums, 2001).

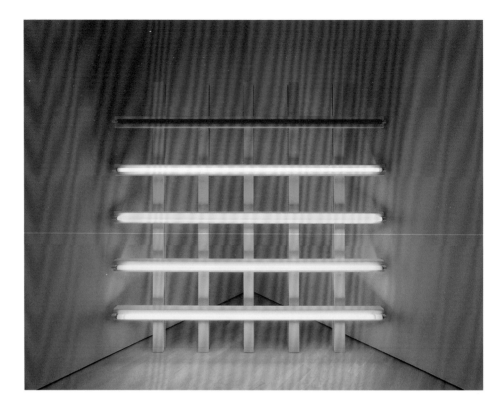

and anti-natural colors, transforming the well-known image into an abstract form of visual expression devoid of meaning and reference in order to instill it with reflexive qualities.

Dan Flavin expanded this artistic excursion into industrial modernity. Using fluorescent light fixtures, he turned everyday objects into art. However, Flavin's grid of light fixtures (*Untitled* [*in honor of Leo at the 30th anniversary of his gallery*], 1987, p. 24) is not a self-evident form, but rather creates immaterial abstract images. These appear as three-dimensional illusions, as the fixtures project onto architectural structures, most often the corner of a room. Adding to this complexity is the fact that Flavin embraces modes of architectural perception that depend on movement. Flavin in this way alters the stable and static quality of the painted grid in order to provide contingent perceptual experiences that change with the movement of the onlooker. His grids of light tubes, which vary in size, radically transform the grid as a flat form into a three-dimensional object. More significant, however, is the fact that his lattices create new images rather than speaking to the grid's quality as a self-referential form of the visual.

III.

Artists also didn't shy away from testing the grid's resistance to sequence and narrativity. László Moholy-Nagy's *Dynamic of the Metropolis* (1921–22, pp. 46, 50–51), a film script later published in book form, makes this evident through the use of both the medium of the book and that of film as they conventionally unfold through sequential order. Moholy-Nagy divided each book page into a Mondrian-like grid of horizontal and vertical lines, establishing irregular geometric blocks. He filled these blocks with photographs, signs, and text, laying them out as a collage in experimental typography typical of Bauhaus design. The never-realized film script negotiates the pure visuality of the grid against the synchronous experience of speed and motion, violating the senses through incoherent arrangements of bits and pieces of texts and images that generate an effect similar to perceptual experiences provided by the modern metropolis. Grid and collage form new relations between experiential reality and abstract form. While the grid assists with giving some rest to the continuous perceptual exhaustion of the metropolis, images and texts inflect the grid with content. We cannot help but read single words such as the recurring "Tempo" or "Fortissimo," notice the unusual perspectives of photographs that often reproduce fragments of a world set into motion, and finally study the accompanying film script directives. What Moholy-Nagy visualizes here is an abstraction of the very nature of dynamism, one that celebrates modern urbanity and technology, yet also contains it. The Hungarian modernist above all underscores the perceptual condition of the metropolis as one of divided attention through the way in which he employs the grid, advancing the traditionally narrative media of film and book to visual levels.

In contrast to Moholy-Nagy's montage-like arrangement of disparate, disembedded, and disjointed images and texts, Robert Rauschenberg's *Coda* (1989, p. 56) lays out four fragments of photographs in a seamless four-part grid. Similar to this artist's earlier split screens that use the formal model of the television as a visual ordering device suggesting us at different places at once and disrupting notions of linear time, *Coda* directly confronts the flattening yet also spatializing grid with images that allude to the passing of time: a staircase, a clock, and an urban passage. The photograph in the lower left shows architectural ornaments in the form of discs that recall, via their shape, a clock. They serve Rauschenberg to question the authority of sequential time, as their role within an architectural context is a decorative one. Based on the paradox of placing these images within a grid, a structure that is hostile to time and iconographic references, Rauschenberg

11. See Brandon W. Joseph, *Random Order: Robert Rauschenberg and the Neo-Avant-Garde* (Cambridge, MA: MIT Press, 2003).

establishes a complex relationship between visual representation and the meaning of objects. Although the visual field appears unified, we are asked to perceive these images of the past, present, and future synchronically. Also contradictory is Rauschenberg's emphasis on a flat picture plane which, in this case, is made out of aluminum. Comparable to Dan Flavin's light fixtures, the aluminum object with its strong material presence challenges the notion of art as illusionism. Finally, seen together, the reproduction of images referencing urban spaces and the aluminum object generate a complicated discourse on representational fixity, inquiring into the discrepancy between an object and its imitation, original and copy, illusion and real, and between here and there. Rauschenberg thus highlights the qualities of split screen televisual perception that allow for the simultaneity of the non-synchronous, for multiple perceptual sensations at once, elucidating our loss of experiencing the passing of time as it is also emphasized through the pure visuality of the grid.[11]

IV.

These aesthetic incarnations of the grid that span the twentieth century illustrate artistic practices that engage the grid as a form of pure visuality while pressing its boundaries, testing its resistance to experiential reality, be it popular or material culture, narration, or mimesis on one hand, or illusionism and spirituality on the other. Hence these grids dialectically pose pure representations of the visual against context and discourse, demonstrating the impossibility, even in the realm of aesthetics, of this purity. In that respect Rosalind Krauss's thesis of the grid as a highly inflexible structure proves to be entirely correct. Only the computerization of the grid, which transformed its stable and static structure into a moving and constantly changing one, has altered the nature of the grid. These digitally encoded grids, or matrices, may or may not reveal themselves in the finalized aesthetic product, but they always and with certainty produce new images.

While the analog grid never ceases to surprise us through its minimal and simplistic form, which in all of its various manifestations remains essentially the same, artworks based on a matrix draw our curiosity by virtue of their technological skill, as sophisticated painting

techniques did in the past, for example. Furthermore, instead of repeating a singular, stable structure, matrix art returns to an aesthetics of originality, creativity, and imagination. These works embrace what the grid rejects, namely language, discourse, time, mimesis, and illusionism—in short, what Krauss described as anti-visual qualities.[12] French philosopher Jean-François Lyotard has moreover theorized the matrix as an order beyond the visible, one that is out of sight, invisible, capable of joining logically incompatible elements which establish what he qualifies as bad form rather than Gestalt.[13] According to Donald Kuspit, however, matrix art makes the creative act explicit as a deeply emotional and subjective process, one that deploys material sensation and the process of becoming.[14]

Notably, much of matrix art also changes our notion of the artwork as finite, permanent, and self-contained: repeatedly this art revises the relation between onlooker and artwork. The former either is an active participant who produces various iterations of an artwork, as in Jeffrey Shaw's *Legible City* (1988–91, pp. 28, 64), or is enticed to interact with the art to a degree to which the boundaries between artwork and external world blur. Often the traditional distance between the viewing subject and the object of the artwork is eliminated, replaced by a relation that actively engages the viewer not only on an intellectual level but also on a physical one. More often than not this is already accomplished, at least in part, through the enormous dimensions and spatial expansiveness typical of much matrix art; sheer size requires the viewer to move around the artwork in order to experience it, which automatically prevents a fixed or stable perception.

Julius Popp's *Bit.Fall* (2006, pp. 66–67) is one example that demonstrates, in contrast to works based on an analog grid, vast proportions. *Bit.Fall* comprises an enormous water wall (when installed, often measuring twelve feet in height and eighteen feet in length) that incorporates cultural information—in the form of words—into the ephemeral medium of falling water, where words seductively materialize before disappearing. The viewer is enticed to move toward, away from, and around the monumental and transparent water curtain in order to grasp how technology has been

12. See Rosalind E. Krauss, *The Optical Unconscious* (Cambridge, MA: MIT Press, 1994), 217.

13. As discussed in Krauss, *Optical Unconscious*, 217–25.

14. See Donald Kuspit, "The Matrix of Sensations," http://www.artnet.com/magazineus/features/kuspit/kuspit8-5-05.asp (cited August 5, 2006).

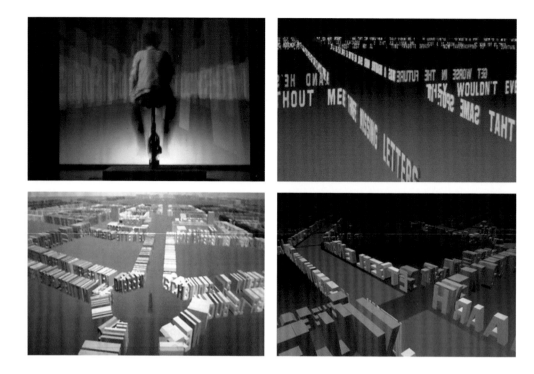

employed to visualize words as falling water drops, to reflect on the meaning of those words, and, not least, to admire the beauty of this sculptural installation, particularly the comforting, innocuous, and mesmerizing raining drops of water. For *Bit.Fall* Popp uses a computer software program that selects the most frequently found words on Internet news sites; this digital information is programmed in such a way that it ejects, through magnetic valves on 240 jets suspended from the ceiling, water dropping in the form of these words. Importantly, Popp creates a closed circuit: the water drops are collected by a basin then pumped back into the jets, through which he visualizes the constantly changing information of our daily reality, as if the artwork would be able to halt the flux and temporality of information overload, and prevent any damage it might cause. Yet *Bit.Fall* also repeats the phenomenon of fluctuation and instability as the words vanish within seconds and transform on a daily basis. Popp's waterfall is not a conventional one that offers contemplation and retreat from reality, but one that is constantly changing, always looking different, never just an object of sensual delight and pleasure. Rather, it heightens consciousness about our contemporary condition. The digital code of the most used words is not the one we see as a bitmap of water drops raining from the

ceiling. The matrix of the water curtain is in fact a simulacrum that is played out against the analog technology of the waterfall. As with other matrices, what we see is not what we believe we see.

Jeffrey Shaw's *Legible City* also uses letters, words, and text rather than images to assist us in navigating the world, urban sites in particular.[15] For this work Shaw transformed Manhattan, Amsterdam, and Karlsruhe into a virtual environment where architecture turns into language and narrative sequences. Nevertheless, as if he distrusts language and logical content, his installation projects these textual architectures as surreal visualities.

Shaw's installation is based on interactivity. Unlike *Bit.Fall*, which we want to touch and experience bodily, *Legible City* relies for its constitution on the viewer turned user or player. The player in Shaw's work rides on a stationary interface bicycle, to which is attached a small computer screen simulating the user's position as she navigates the virtual city and its ground plan. With the handlebars and pedals the user controls her speed and direction while the computer projects her movements through the virtual terrain onto a large screen which other viewers see. While the Manhattan project has eight different narratives from which the player can choose, the Amsterdam and Karlsruhe versions of *Legible City* represent letters that are identical in scale and location to the actual buildings in these cities. The texts for these two cities are largely taken from archival documents. Both versions have a much more representational character while the Manhattan one is more fictional and open-ended. Yet in all three versions the city appears as real structure, transformed into letters and words through which a user can stroll on a bike, and also as an immaterial and virtual one. Shaw's matrix is constituted through various user-generated movements and manifest as images on a large screen that display language and historical narratives about those specific sites. These images, not the matrix which remains invisible, resemble the real and the historical while at the same time undermining it. In fact, Shaw asks us to newly consider what is real, what is staged, and what is simulated, and to reflect on the relation between those visual representations. His city visualizations reference an original and thus cannot be simulacra, or copies for which no

15. See Jeffrey Shaw, *The Legible City*, www.jeffrey-shaw.net/html_main/frameset-works.php3 (cited August 18, 2006); and Anne-Marie Duguet, Heinrich Klotz, and Peter Weibel, *Jeffrey Shaw—A User's Manual, From Expanded Cinema to Virtual Reality* (Ostfildern: Cantz, Edition ZKM, 1997).

original exist. At the same time, the projections generated by the players are simulacra insofar as they are only made possible through virtuality and the computer-generated matrix.

V.

The situation is completely different once we consider digital photography. Digitization, I propose, thoroughly and forever changed what we typically understand the nature of photography to be, namely to reference something factual in order to impart truth. Furthermore, digital photography has, according to this understanding, significantly changed our relationship to the factual and real to the extent to which we can no longer take representations of "the real" for granted; we have to consider reality as a construction in the first place. Of course digital photography does not completely deviate from fact and history insofar as it still renders visible people, objects, and sites that we know from experiential reality, and still appears to freeze a real moment in time. That is, at least, what we like to believe when we gaze at German photographer Andreas Gursky's *Library* (1999, pp. 70–71), for example. But that is also exactly what complicates the situation: we cannot trust that a photographic reproduction is not manipulated to such a degree that image and referent no longer have much in common with each other. Photography, since its very inception, has experimented with different methods of imbuing the photographic image with subjective, fictitious, or imaginative qualities. Now, however, with digital technology the option exists to entirely emancipate the image from its referent—but without necessarily revealing this manipulation. As much as this might complicate our relationship to photography and perceptions of reality, so too does it liberate photography from documentary responsibilities and referential logic. Thus the flexible matrix, the binary electronic code with its underlying grid structure, endows photography with fresh opportunities to shape new relations between fact and fiction, reproduction and imagination, and to replace the photographic tie to things past with a condition that offers open-ended forms of becoming.

Andreas Gursky's large-scale photograph *Library* appears to depict the Stockholm public library. Rather than evincing a documentary

impulse, however, Gursky employs his own visual logic. With an aesthetic emphasis on optical sensation, Gursky challenges the viewer with minute details, demanding a concentrated reception of the photograph while foregrounding an overall geometric order consisting of three circular forms that float in the space and contribute to flattening the image of the library. Gursky, it is obvious, must have manipulated a photograph of the Stockholm library: he in fact omitted the actual floor and its escalators, replacing them with a mirror image of the shelves above. He also repeats certain shelves, objects, and library users, and last but not least enhances colors. Similar to what we usually understand as the task of the medium of figurative painting, Gursky's digital photograph ostensibly aims to create an iconic image of the library in our globalized world. Yet what does this exactly entail? Gursky reproduced an image of an actual library on one hand, but imbued it on the other with painterly qualities as if to remove it from facticity and instead create an autonomous form of pure visibility. As with figurative paintings, Gursky's *Library* represents both fact and fiction at once.

Norman Bryson described Gursky's approach as a dual commitment to observing social reality and to aestheticizing empirical reality in order to enhance a new form of the contemporary sublime, undermining photography's claims to truth and inquiring into subjective dimensions of all representation of the social.[16] Notwithstanding, I would still argue that, given the pure opticality with which Gursky's image convincingly engages, the dialectic is not so much anchored in the relation between the social reality of a networked and homogenizing global world and artistic subjectivity, but between the modernist ideal of the autonomous image and the photographic investment in fact, truth, and history. The latter is what Gursky attempts to complicate as he releases the image from its particularities and historic moment. Moreover, the photograph resists any corporal relation to the photographed and to the viewer, creating an absolute distance between art object, viewing subject, and factual referent. Gursky's library in that sense exists on its own.

What I want to suggest here is that Gursky's Stockholm *Library* embodies a postmodern form of the analog grid. It does so by using

16. As noted by Nancy Spector, http://www.guggenheim collection.org/site/artist_work_md_59A_1.html (cited August 18, 2006).

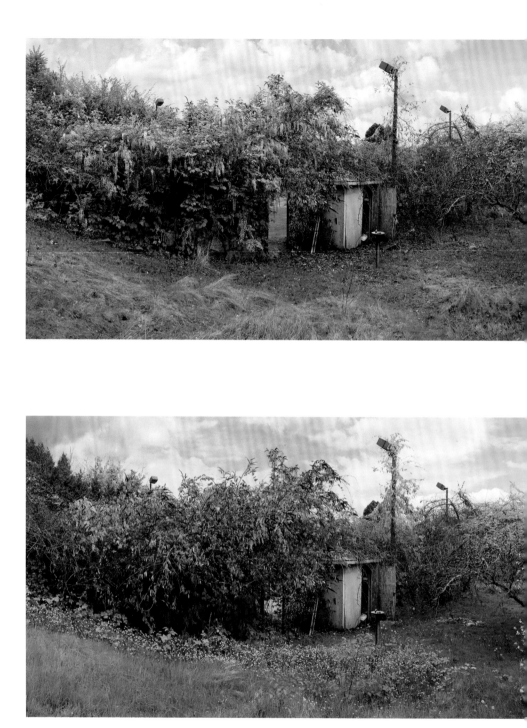

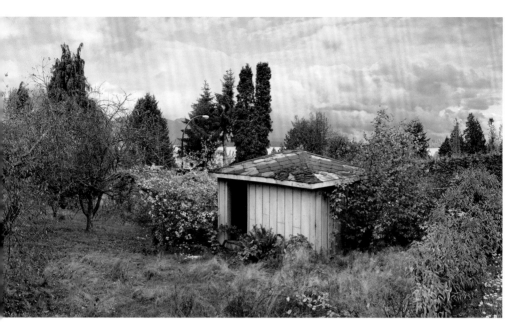

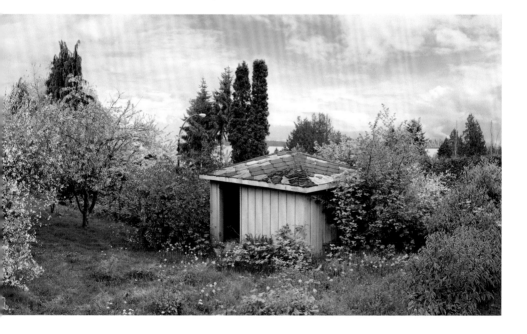

Scott McFarland
Orchard View with the Effects of Seasons (Variation #1), 2003–6 (top)
Orchard View with the Effects of Seasons (Variation #2), 2003–6 (bottom)

the advanced technology of digitization, yet it demonstrates defining and critical qualities of what we have discussed in the context of the modernist grid: the image is flattened, it suggests infinite continuation beyond its own boundaries, it highlights the repetition of various elements, and it finally asserts an absolute distance from life—from the context of the viewer and a factual library. In other words, the digital matrix here—at work through the binary photo-technology Gursky employs—brings about a visual universe that is absolute, pure, and autonomous from time, narrative, and social and factual context. Of course, though, Gursky's image is not identical with itself but is simulated by a matrix.

By contrast, the digital photographs of Canadian artist Scott McFarland negotiate both factual landscapes, including their various visual appearances during different seasons, and the process of artistic intervention, via digital manipulation. His *Orchard* images (pp. 32–33, 76–77), each one consisting of a series of negatives taken over a period of several weeks, always shot at the same time of the day, are digitally mastered into coherent and seamless photographs that openly acknowledge the possibility of endless digital alterations: the single image never resembles a finalized aesthetic product. In contrast to Gursky's, McFarland's images prompt us to wonder what the real orchard looks like. McFarland's images are neither fixed nor stable: instead of reproducing a single moment, as with analog photography, his inclusion of a series of moments offers fresh visual iterations of an original referent that has lost its unique quality.

Yet like Gursky, who generates a discourse on the modern ideal of the autonomous image in the age of globalization, McFarland also dwells on historical antecessors, namely the genre of landscape painting. Ever since the nineteenth century, the landscape in art history has promised retreat from social reality and an immersion into the imaginative realms of the creating subject, also suggesting our ability to civilize, cultivate, and shape the land we inhabit—in other words, the power to transform nature into landscape. McFarland already chooses an example of a manmade landscape, namely that of an orchard, as guiding motif for his digital alterations. The garden, an aesthetic environment that promises beauty, pleasure, and relaxation,

advances in the hands of McFarland to an object that challenges truth-value, putting us at unease with what we see. If we compare *Orchard* to *Orchard* (*Orchard View with the Effects of Seasons (Variations #1 and #2)*, 2003–6), we discover a lack of coherence that debunks the artist's scientific project of photographing the orchard over and over at exactly the same time of day. In fact, the two *Orchards* show a montage-like combination of photographs of the same plants and trees in various seasonal incarnations. We experience the photograph like a puzzle, trying to discover if the orchard is reproduced during summer, spring, or fall. At the end we come to realize that McFarland combined all three seasons in one image as if to underscore the artificiality of the garden in the first place. He not only reveals the making of this artifice—the digital montage of different moments presented as one—but through this very process also challenges our relation to reality as he asks us to consider whether what we see indeed exists. He does that by expanding the medium of photography that usually reproduces one single moment to a series of moments that coexist, erasing sequential narration and historical time. McFarland's digital matrix plays with the grid's embrace of repetition and synchronicity while simultaneously including the world beyond the silence of visual art. His project frees the artist from the rigid confinements of pure visibility, opening avenues for creative interventions that inquire into our relation to the natural environment.

In a similar manner Pakistani artist Rashid Rana also thematicizes the new medium of digital art; his aesthetic strategy, however, references the grid in an even more deliberate way. Like McFarland's, Rana's photographic work depicts multiple and often contradictory versions of reality, all of which are fabricated through the computer.[17] *A Day in the Life of Landscape* (2004, pp. 40–41) is modeled after a painting of the same motif by Khalid Iqbal, one of the artists of the Punjab Landscape School active in the 1980s in Lahore, Pakistan. Rana's appropriation at first looks like an Impressionist rendering rich with visual sensations. Upon closer inspection, however, we see that Rana's photograph consists of a grid of many small photographs of the urban scape of Lahore—not the beautiful landscape we think we see (p. 42). He thus reveals not only

17. See *Rashid Rana: Identical Views*, exh. cat. (Mathuradas: Spenta Multimedia 2004), 10, 21.

35

Albert Oehlen
The Annihilator, 2001–6

the unity and coherence of the digital photograph as perceptual illusion, but also renders a matrix as a grid in order to demonstrate its capacity to create images that have nothing in common with its own visual appearance. On one hand, we may argue that the grid serves Rana as a device of visualization, giving form to a landscape; on the other, we must understand the grid as a matrix, for the grid of miniature urban scapes generates not its own image but another, a contemplative landscape that is, in fact, a manmade construction.

VI.

The matrix also found its way into the medium of painting, not only the most contested genre in twentieth- and twenty-first-century art history, but also the one which seemed most vulnerable to the innovations of technology, mass culture, and their effects on the arts. The critical issue of the validity of artistic subjectivity and autonomy, which were seen as inopportune and inadequate to meaningfully mediate modern existence, was debated over and over again. Some critics, such as Clement Greenberg and Werner Haftmann, attested that the medium of painting would realize itself through the visualization of such an unmediated creative process.[18] Others, however, were suspicious of the very existence of a wholesome subjectivity in the face of a thoroughly technologized world.

Exactly this discourse is at stake in Albert Oehlen's *The Annihilator* (2001–6, pp. 36–37).[19] Since the early 1990s Oehlen has created paintings produced on a computer and reproduced on canvas with a large format inkjet printer. *The Annihilator* is such an inkjet print on canvas, which in this case Oehlen also over-painted with oil and lacquer. The painting renders an unpredictable and dynamic chaos of abstract layers of color patchworks and lines, interspersed, surprisingly, with some grids. For those who have used imaging software, it is immediately obvious that a computer was at work here; Oehlen lays bare the electronic making of the painting. His own added painterly marks can be seen as a conceptual strategy that engages human creativity with that of a computer. With this approach Oehlen challenges the very possibility of painting an abstract and expressive canvas today. Yet we might also grasp his large-scale painting as

18. See Clement Greenberg, "Modernist Painting," in *Modernism with a Vengeance, 1957–1969*, vol. 4 of *The Collected Essays and Criticism*, ed. John O'Brian (Chicago: University of Chicago Press, 1993), 85–93; and Werner Haftmann, *Painting in the Twentieth Century*, trans. Janet Seligman (New York: Frederick A. Praeger Publishers, 1965).

19. The title *Annihilator* could refer to the well-known trash metal music band based in Vancouver, British Columbia, yet also to digital imaging software of the same name.

putting a positive twist on the effect of computer generated images on the medium of painting, namely that the combination of digital innovations with conventional traditions of painting, opens up new avenues for creativity and the creation of imaginative worlds.

20. See Kuspit, "Matrix of Sensations."

The code, the invisible matrix, creates an abstraction that embraces, in contrast to the grid, visual creativity. This visuality is not absolute, as with the modernist grid, but informed by a new form of subjectivity, one that is enabled by advanced technology. Oehlen's enormous painting, with its all-over painterly surface devoid of the confinement of a frame, manifests itself as an object in its own right, suggesting a whole new world of creative imagination. Importantly, though, this creativity is not one fashioned in a *l'art pour l'art* realm, divorced from technology and modernity, but one that is created through it, bringing our discussion about grids and matrices full circle.

Donald Kuspit has claimed that since the second half of the twentieth century the image has become secondary to the abstract code (or concept, as he also calls it) which he sees as the primary vehicle for all creation now.[20] Due to the immaterial code, the image no longer exists on its own. The grid, however, has taught us that it never did in the first place, but always constituted itself in the dialectical relation between pure image and external context, between the ideal and experiential reality, silence and narration. The matrix, as we have seen, complicates this: it fashions new images that depend on the immaterial and invisible code. Yet all artworks discussed here thematize exactly this: the relation between the invisible, the matrix and the new image generated by it, on one hand, and, on the other, the grid, embodying pure and self-contained visuality. As much as grid and matrix, image and non-image, form and non-form, the visible and invisible, depend on each other, so too do grid art and matrix art thematize this central dialectic.

SE

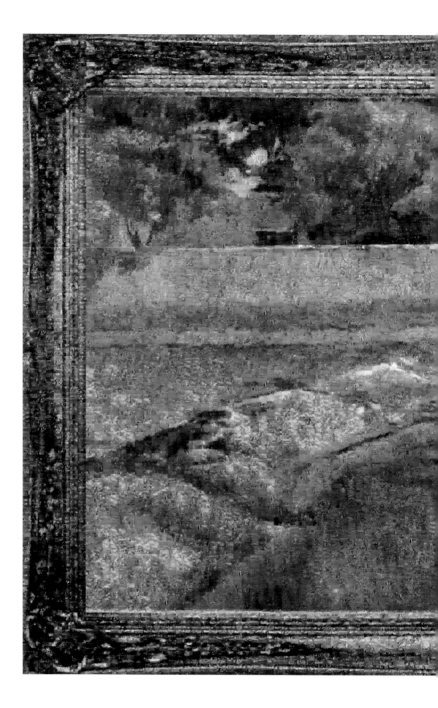

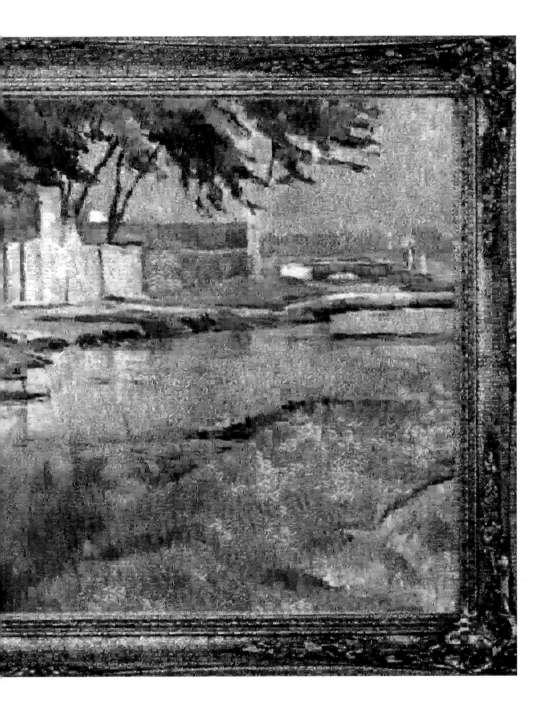

Rashid Rana
A Day in the Life of Landscape, 2004

Matrix

What is the matrix?

The matrix is the womb: the point of origin, the source of growth.[1]

From the Latin *mater*, or mother, the term is used in post-classical Latin and early modern texts to designate the uterus or the ovaries.

The matrix is a structure that embeds, encloses, and supports.

It is the rock that surrounds gems, fossils, or metal. It envelops cells and forms the substance of connective tissue. It is a fine material, such as lime or cement, used in construction to bind coarser matter.

The matrix is a model or prototype, an object from which copies are produced and reproduced.

It is the metal block in which a character is engraved, creating a mold for printing. It is a copy of an original disc recording of music, used for generating further copies for distribution. It is the material that serves as the temporary wall of a cavity while a tooth is being filled.

The matrix is the symbolic, rectangular representation of otherwise hidden concepts or functions.

It is a grouping of numbers, symbols, or mathematical functions arranged in rows and columns and treated as a single unit or entity. It is a truth table in logic, an array of symbols representing the potential truth-values of a given proposition's elements. In computing, it is an arrangement of possible image points.

The matrix is a system, a network of interconnections and its elements.

In today's world one speaks of the political matrix, the social matrix, and the economic matrix. Both work and play are performed on the matrix, the global network of electronic communication. *The Matrix* (1999), the Wachowski Brothers' film, begs its audience to consider the nature of reality and to question its very existence. As a consequence of the success of this film there now exists, at least in our imaginations, the Matrix: a fictional, digitally-generated world created by machines to keep humans captive and ignorant of "reality."

1. Definitions of the term "matrix" appearing here are adapted from the *Oxford English Dictionary Online*, http://www.oed.com (cited June 30, 2006).

The matrix creates.
The womb houses the conception and growth of new life, and from its
security and darkness the child emerges into the world outside. Digital
codes determine the sensory data the inhabitants of the Matrix perceive
while encased in their gooey pods and those to which gamers react while
engrossed in their games; the code produces the warmth of the sun, the
squeal of tires, and the taste of steak. The graphic designer or artist employs
computer matrices, those rectangular arrays of possible image points, in
order to create compositions. The advent of digital culture has allowed
new means of production, alteration, distribution, communication, and
reproduction, and with them countless new products and experiences,
whether commercial, political, social, or aesthetic.

The matrix adds dimensions.
Mathematical matrices allow many symbols or functions to be considered
singly; the one-dimensional number, for instance, becomes a two-dimensional
set of rows and columns, allowing for the simultaneous manipulation of
many rather than of one. The matrix also makes four-dimensional what was
once two- or three-dimensional by introducing the element of time. Without
time, the womb is merely an organ taking up space in the torso; with time, a
fertilized egg protected by the uterus becomes new life. Computer matrices,
including the network of international communication made possible by
the Internet, allow the grid, inherently fixed, to move, change, and shift; the
modification of input data over time precipitates an alteration of output.

**The matrix masks: it makes perceptible the surface and product while
hiding the creative content or form.**
Letters appear on the page but not the mechanism of mold, press, and ink
that produces them. The womb protects the fetus's senses from the onslaught
of input from the outside; at the same time, it conceals the process of
gestation from the already born. One sees the human product after its birth
but cannot witness its creation. Images and text on a website are visible but
not the code that determines them. Even the designer of the website merely
manipulates already existing programs in order to produce the desired
effect; only the most skilled of programmers at the vanguard of computer
engineering have access to the structure behind the façade.

The matrix penetrates, permeates, and saturates.
The mortar enters the pores of the brick where it hardens, connecting it
to the system of bricks that forms the construction. Tissue surrounds the
body's cells and binds them. Social, economic, political, and structural
systems are called matrices for the very reason that their breadth, depth,
and interconnectedness are all-encompassing. The Internet has pervaded,
in an incredibly rapid manner, almost every aspect of the societies that rely

on it. Not only has it become fundamental, instrumental, and necessary for the efficient functioning of business, the academy, and government, it has also become a primary mode of entertainment, communication, and social engagement, including sexual interaction. Digital culture has saturated our lives so thoroughly that it has become almost impossible to determine where the virtual world ends and "reality" begins.

The matrix reproduces.

The womb ensures the perpetuation of the species. The metallic, engraved matrix allows for mass duplication of the printed word. From the matrix of a recorded piece of music come the countless copies that define the contemporary music industry. In the digital matrix, novel programs are born from previously existing ones, while hypertexts, links, and search engines on the Internet allow for new and often spontaneous connections among various texts and ideas. In *The Matrix Revolutions* (2003), the Wachowski Brothers' third *Matrix* film, a pair of married computer programs, represented visually as humans, reproduces, resulting in another computer program perceived by the inhabitants of the Matrix as a living, breathing child. The matrix, then, returns to its origin: it becomes the womb once more.

The matrix allows for seemingly endless possibility.

Just as combinations of only four chemical bases in billions of base pairs, countlessly divided into eggs and sperm and multiplied by billions of possible sexual partners, leads to practically endless variations in the reproduction of human genetic data, so too the combination of zeros and ones over billions upon billions of repetitions creates seemingly limitless possibilities for digital data. Although at any given point in time the data being stored and used is finite, the programmer's continuous ability to add memory allows for potentially infinite information.

What is the matrix?

The matrix is the source, the model, and the code. It is the content that generates and the surface that is generated. It is dynamic. The matrix links and binds, pervading organic tissue, social structures, and cyberspace. And it is a word, when considered in its entirety, that assimilates these various meanings simultaneously. The matrix thus engulfs, whether parasitically or symbiotically, almost any concept or structure, like rock settling around gemstones, fossils, and whatever else occupies the space it has come to claim.

The matrix is everywhere.

Gwyneth Cliver

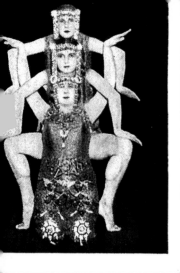

TEMPO TEMPO
TEMPO

ETé,
ge Tätigkeit.

nringkampf.
n.

andinstrumente
aufnahme).

Fußballm
Grob.
Starkes T

Metallkegel—innen
leer, glänzend —
wird gegen das Ob-
jektiv geschleudert,
(inzwischen)
2 Frauen ziehen
ihre Köpfe blitz-
schnell zurück.
Großaufnahme.

(Um das Publikum zu er=
schrecken. Auch ein dy=
namisches Moment.)

László Moholy-Nagy
Dynamic of the Metropolis (detail), 1921–22

(Grid<>Matrix): Take II

Users of imaging software are well familiar with this: as you try to crop or manipulate specific areas of a digital image on screen, your cursor seems to jump magically to certain positions and, even after more nuanced interventions, remain bound to an invisible lattice of horizontal and vertical lines. Hit CTRL + ' in the market's leading imaging software and you'll be able to reveal this grid that is secretly organizing the distribution of elements across the screen's surface. Go into "Preferences" or "View" and you might succeed in disabling the program's "snap to grid" function. It will emancipate the movements of your mouse, allowing your cursor to wheel more freely through the image, but it will not, of course, eliminate your file's most basic grid, the network of perpendicular lines that situates individual pixels within an unflinchingly predictable structure.

More advanced users may try to trick their image's basic grid. They will place different pictorial layers on top of each other, warp individual areas into impossible shapes and sizes, put to work different filters, masks, and distortions, blend material with dissimilar resolutions and pixel aspect ratios, or multiply or deform the image's grid to such an extent that we may no longer suspect its principal

existence. But in the end, we find that even such expert users will not entirely suspend the rigid logic structuring digital information at its most primal level, unless, of course, we let go of what we tend to consider "the end" in the first place, unless we recognize the extent to which time, flux, and temporal openness reside at the very core of what we call an image today. Let us employ animation software to render our document dynamic and situate it within a larger series of pictures in motion. Or let us simply pipe our image through the conduits of cyberspace, making it available to other users' acts of manipulation, and hence bring into play one of the perhaps most dazzling features of digital culture, namely its aesthetic of the unfinished, of unlimited dispersal, reiteration, and transformation, of unfixity and endless change. The grid, at the most basic level, might never go away, but we have no reason to think of it as a static structure, an iron cage imprisoning spontaneity and the unpredictable, a wicked Medusa that will petrify all living things. As much as digital culture may reduce what is continuous to binary oppositions between zeros and ones, it also has the power to generate motion, to engage us in infinite processes of becoming and transformation, and hence to end our very notion of "end." To "go digital" is to reconstruct the world within a grid of discrete values. As importantly, it allows us to explore grids as tools of creativity and movement, as principles of producing infinite patterns and variations, and as sources, origins, and codes of the new, the random, the unpredictable—as that which we here call the matrix.

Grids are, of course, not the exclusive property of our age of digital reproduction and art. Among others, they played an important role in the formation of aesthetic modernism, the quest of early twentieth-century artists to sever ties from older doctrines of reference, representation, and social responsibility. This essay sketches the conceptual trajectory from the modernist grid to the digital matrix, my primary aim being not only to better understand the specificity of aesthetic experience vis-à-vis digitally mediated works of art, but also—by rethinking the past from the vista of the present—to recall the modernist grid as much less homogenous and unified than is often assumed. As conceptualized here, grid and matrix form a profound dialectic of modern and contemporary art. Like Nietzsche's

famous antagonism between the Apollonian and the Dionysian, grid and matrix define two distinct modes of aesthetic representation and experience. Each of them stands for fundamentally different principles and politics of artistic production, yet neither can properly be understood in isolation from one another, and both of them simultaneously need and energize the other.

I.

In the 1925 German edition of his book *Painting, Photography, Film*, Bauhaus member László Moholy-Nagy envisioned all kinds of strategies to emancipate photography from the dominance of Renaissance perspective and to enable creative ways of seeing the modern industrial world. One of his proposals was to develop "[c]ameras with systems of lenses and mirrors which can encompass the object from all sides at once and cameras which are constructed on optical laws different from those of our eyes."[1] Moholy-Nagy's futuristic cameras were designed to capture the multiplicity of overwhelming visual stimulations and accelerated distractions that he, along with many other intellectuals of the time, understood as the defining element of metropolitan experience. Their purpose was to provide a means to map and order what seemed to escape traditional methods of structuring the field of perception, namely the flood of discontinuous impressions caused by the ceaseless movements of urban crowds, by the speed of modern transportation systems, and by the ever more domineering role of new media such as film and photography themselves. To view certain objects or constellations from all sides at once, for Moholy-Nagy, was to beat the logic of modern speed, technology, flow, and fragmentation at its own game. It meant to transpose the pulsating rhythms and chaotic itineraries of the modern city into visions of radical simultaneity, to produce mechanical and prosthetic images able to collapse traditional distinctions between here and there, between now and then, between today and tomorrow.

In the early 1920s, with the idea of such cameras in mind, Moholy-Nagy developed a script called *Dynamic of the Metropolis* (pp. 46, 50–51) that sought to transform the time-based art of film into a multifocal medium projecting structured visions of simultaneity. In his preface to

1. László Moholy-Nagy, *Painting, Photography, Film*, trans. Janet Seligman (Cambridge, MA: MIT Press, 1969), 32. First published in German as *Malerie, Photographie, Film*, Bauhaus Book series, vol. 8 (Munich: Langen, 1925).

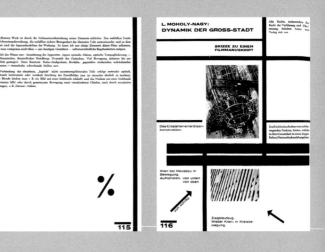
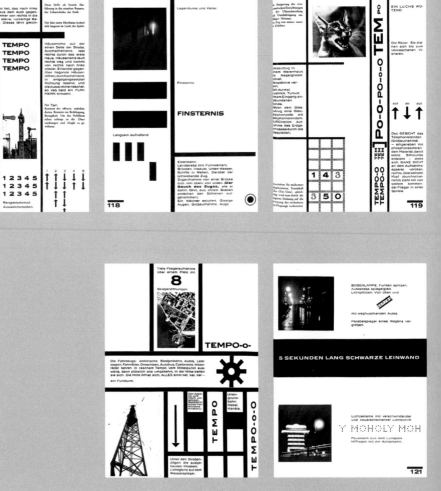

László Moholy-Nagy
Dynamic of the Metropolis,
1921–22

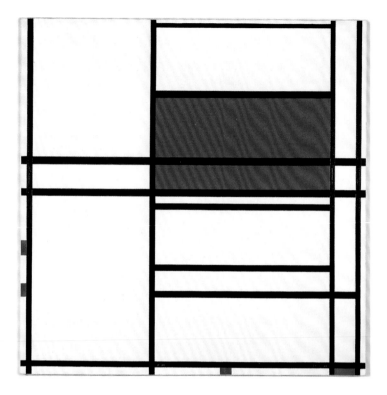

2. Ibid., 123.

the printed script—published in *Painting, Photography, Film*; the film itself was never shot—Moholy-Nagy presents his project as an assault on existing beliefs in temporal continuity and logical order:

> *Individual parts which do not 'logically' belong together are combined either optically, e.g., by interpenetration or by placing the individual images in horizontal or vertical strips (so as to make them similar to one another), by a diaphragm (e.g., by shutting off one image with an iris-diaphragm and bringing on the next from a similar iris-diaphragm) or by making otherwise different objects move in unison, or by associative connection.[2]*

The fourteen script pages that map out the project closely follow this intention. Black lines and edges divide each page into smaller fields

Piet Mondrian
Composition of Red and White, 1938–42

and disparate frames, filled with photographs, captions, individual words, signs and symbols, numbers, and typographical word poetry. Unlike such contemporary montage filmmakers as Sergei Eisenstein, Walther Ruttmann, and Dziga Vertov, whose films assemble ruptured impressions and shock-like visual fragments over time, Moholy-Nagy aspired to spread disparate visual elements within and across the frame of one and the same image. In doing so, his script not only defies any sense of temporal linearity and narrative, it seems to turn film against itself, to display the accelerated rhythms of modern urban realities as if seen from the standpoint of a spectator situated somewhere outside of the pace of ordinary time. And what helps Moholy-Nagy to organize this peculiar view of modern life is nothing other than the rationalistic structure of the grid: geometric patterns of perpendicular lines that mimic the rationalist geometry of metropolitan street design. At once representational and highly abstract, the grids of *Dynamic of the Metropolis* convert time into space; they map linear developments as relational phenomena of simultaneity and present the city as a terrain we might fully understand only if we transcend the biological limitations of embodied vision.

Grids organize or map the visible world according to a predictable system of vertical and horizontal lines. They structure the world as if it entirely corresponded to geometric principles and allow us to assign exact coordinates to every element of the visual field. Grids dissect, frame, and reconstitute the phenomenal world for us. They energize sensations of control, power, and omnipotence as much as they might bestow feelings of claustrophobic closure, of sense-less abstraction, of unbearable rationalization. A world engendered or represented as a grid gives the impression of being entirely knowable and calculable. It has nothing to hide; it contains no dark secrets; it impedes our desire for and our fear of getting lost, of being struck by the incommensurable, the unexpected, the aleatory. Grids thus arrange the perceptible world as something that more or less excludes the possibility of chance and surprise. What you see when encountering a gridded world is not a product of the unpredictable temporality of a viewer's physical movement and sensory perception but of a prearranged logic of compilation and construction, a mechanism

3. Rosalind E. Krauss, "Grids," in *The Originality of the Avant-Garde and Other Modernist Myths* (Cambridge, MA: MIT Press, 1985), 8–22.

seemingly engineering uniformity, universality, and unwavering stability. Though often seen as essentially modern in nature, grids ultimately present the world as something that is void of time and change, void of history, void of what would distinguish the modern from what might precede or follow it. The grid is one of modernity's most stunning myths. It turns modern rationality, efficiency, and calculability into our ineluctable fate; it removes the messy, the strange, and the mysterious and entertains the modern subject with sensations of unmitigated presence and wholeness. To live in a world of grids is to live in an ongoing Now. It is to emancipate oneself from any troubling past or anxiety about the future and inhabit one's present as if it could never be haunted by any sense of absence, of non-being, of death and failure.

Rosalind Krauss has famously argued that, in modernist painting, grids play a decisive role in the artistic endeavor to convert three-dimensional extensions into two-dimensional flatness and thus to focus one's attention on the pure materiality of the canvas.[3] But, as Krauss added, the function of the grid in the work of such artists as Piet Mondrian is by no means unified. It is, in fact, quite ambivalent, providing a structure open to multiple readings and appropriations. On one hand, Mondrian's grids, as they translate the experience of modern urban planning into a painting's organizing principle, relinquish perceptions of spatial depth and temporal extension; they present the image as a self-enclosed mapping of space onto itself, thereby defending the purity and autonomy of the image against the intrusion of the ordinary world. On the other hand, in paintings such as *Composition of Red and White* (1938-42, p. 52), Mondrian presents the image not as something entirely co-extensive with the grid, whose frame would coincide with the borders of the grid, but, on the contrary, as one which acknowledges the world beyond the frame. The image here imposes no logical boundaries on the lattice that structures the various color fields; as such it defines the space of representation as merely a fragment of a much larger spread of similar elements and constellations. At once shutting out and acknowledging the world beyond the frame, at once imposing impressions of self-enclosed autonomy and of infinite iteration, Mondrian's grids are puzzlingly schizophrenic in nature. Instead of visualizing a complete triumph

of modern rationality over any remaining trace of uncertainty, Mondrian's grids simultaneously invite centrifugal and centripetal readings. They at once point our attention inward and outward, suspend our perception and stir our appetite for more. Whatever in Mondrian's paintings appears to strive for unencumbered presence, predictability, and aesthetic autonomy is thus wrested away from what cannot but remain absent and heteronomous. Whatever appears to be a product of the grid's unyielding structure surreptitiously speaks of that which may exceed the grid's rational order and control.

4. See Ludwig Wittgenstein, *Philosophical Investigations*, trans. G.E.M. Anscombe (Oxford: B. Blackwell, 1953).

Yet it is in slightly earlier works, such as Theo van Doesburg's 1917 *Composition VII: The Three Graces* (p. 18), that the modern grid's essential schizophrenia, its simultaneity of presence and transcendence, closure and infinity, may become the clearest. Van Doesburg's work consists of blue, red, yellow, and white shapes set against a starkly black background. Though we cannot but fail to identify one consistent pattern defining the exact location of these colored rectangles and squares, their arrangement clearly constitutes a network of horizontal and perpendicular lines, a Cartesian system of coordinates potentially allowing us to locate each individual element according to a two-dimensional grate, a highly predictable web of X/Y planes. And yet, to think of these vibrant squares and rectangles as an underlying grid's mere content, as material produced by and subjected to the ordered grate of the black background, misses the point. Instead, *Composition VII* is reminiscent of the rabbit-duck pictures famously used by such early twentieth-century perceptional psychologists and philosophers as Ludwig Wittgenstein in order to demonstrate both the activity and the ambiguity of human perception.[4] Like Wittgenstein's rabbit-duck experiment, van Doesburg's *Composition VII* questions and collapses ordinary distinctions between figure and ground: it allows us to see the black areas of the painting as the image's underlying grid as much as it, alternatively, invites us to perceive the distribution of colored shapes as that which structures the entire canvas and gives form to the continuous field of black paint. The longer we thus look at *Composition VII*, and the more often we switch between different modes of relating the colored shapes to their black surrounding, the less we can think of the grid as merely an abstract scheme and preceding structure

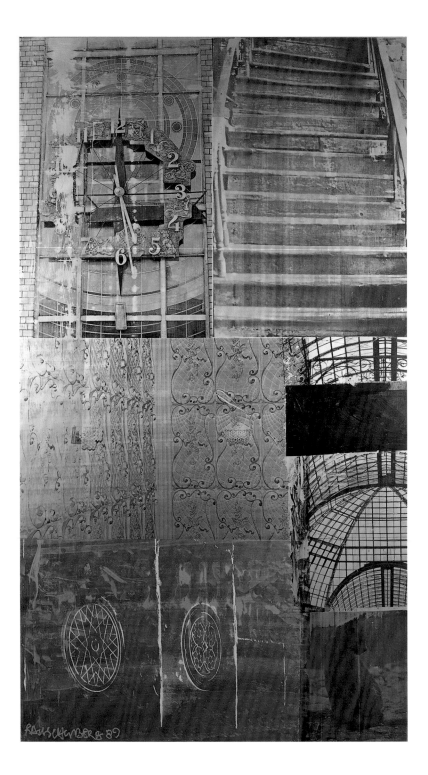

that controls the surface of the visible field, and the more we come
to conceive of the grid as the very substance of the visible world—a
mechanism not simply assigning individual spatial locations, but
producing what we experience as space in the first place. Van Doesburg's
grid is both figure and ground. It problematizes conventional oppositions
between pictorial fore- and backgrounds and in this way involves the
viewer in an unsettling dialectic between the abstract and the concrete,
depth and surface, frame and framed, presence and absence, the bounded
and the infinite, the measurable and the unknowable, completion
and the unfinished. The grid's modernity here radiates triumphant,
but precisely in doing so it also seeks to imbue modern rationality with
mystical and mythical qualities, with an ecstatic kind of spiritualism.
It asks the viewer to find the transcendental amid the pure materiality
and bounded flatness of the canvas, to use the present as a ladder to climb
beyond time.

 Which brings me back to Moholy-Nagy's film script of the 1920s and
its originality, although in a slightly different and more pronounced
key: while translating the experience of urban modernity into the
organizing principles of the page, the grid of *Dynamic of the Metropolis*
also boldly anticipates the multiplicity of windows we encounter
and maneuver when operating our personal computers today. In
Moholy-Nagy's view, modern urban culture produces a profound
multiplication and fracturing of the visual field; it engenders viewers
who, like contemporary computer users, must learn how to gaze at
things multifocally—that is, through multiple frames of reference
and competing windows of representation. Each segment of Moholy-
Nagy's grid contains different snapshots, observations, meanings,
and rudimentary stories, yet in contrast to a conventional film's
storyboard, none of it adds up to a teleological narrative, an integrated
chain of ordered events and elements. What is challenging about
Moholy-Nagy's grid, then, like van Doesburg's, is the fact that it asks
us to refocus our eyes constantly without finding any point of rest or
closure; it invites us to immerse ourselves in parallel temporalities and
logics of representation without offering a privileged sequence, an
intended order of reception, a consistent or hence calculable way of
reading and traversing the grid. The organizing structure of *Dynamic*

of the Metropolis, by prioritizing simultaneity over linear chronology, may turn time into space, but the spatial here undergoes an acute temporalization, a dynamization which ultimately displaces the kind of schizophrenia attributed to the grid in classical modernist painting.

Moholy-Nagy's grid is pluralistic; he allows content to structure the grid and vary the relation of its intersecting lines. It eludes the attributes of seriality and iteration, of predictability and purity so dominant in other modernist versions of the grid. Open toward the edges of each page, Moholy-Nagy's networks of intersecting lines give no indication of how they might continue beyond the border of the book. The grid's bold strokes instead are in open dialogue with the images, snapshots, impressions, words, and mini-narratives they frame. Far from imposing abstract order on certain contents, the grid thus emerges as a means of mapping, exploring, and juxtaposing possible patterns within the visual field itself, patterns that neither exclude nor discipline what meets the urban dweller's eyes as random, aleatory, and unexpected. Whereas Mondrian's and van Doesburg's grid, in the final analysis, sought to rule over the messy materiality of modern life so as to transcend time and attain some kind of universal spirituality, Moholy-Nagy's grid describes the present as a heterogeneous simultaneity of various open-ended narratives, of loose ends and possible connections that still need to be made. The grid here no longer expresses a dialectic of presence and absence, of the ephemeral and the eternal, but one centered on productive tensions between the patterned and the random, between our need to tell meaningful stories and the inevitable entropy and instability of meaning in time.

It is difficult, if not impossible, to imagine how Moholy-Nagy could have turned the script for *Dynamic of the Metropolis* into a real film without radically challenging the established methods of cinematic projection and reception. The quadruple frame of filmmaker Mike Figgis's digitally recorded *Timecode* (2000) comes much closer to Moholy-Nagy's strategy of capturing the plurality of urban experience than the aesthetic of temporal montage in such legendary films as Ruttmann's *Berlin, Symphony of a Big City* (1927) or Vertov's *The Man with a Movie Camera* (1929). And yet, even Figgis ends up telling a relatively integrated story, one in which individual

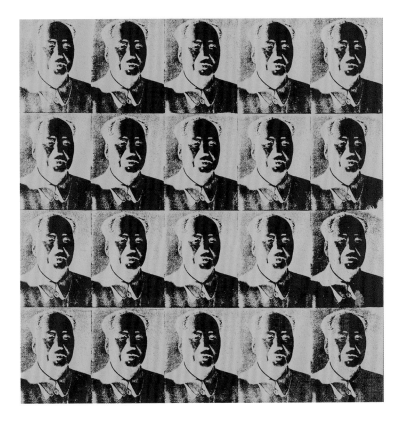

frames of representation remain directly related to each other and the screen's defining grid remains stable throughout the film's ninety-seven minutes. What makes it difficult to imagine how Moholy-Nagy could have finished his project is the fact that he employed the grid as a central element valorizing the unfinished over the completed, the openness and productivity of historical experience over aesthetic closure. In doing this, Moholy-Nagy tried nothing less than to mobilize the modern grid against itself, to make it do what it categorically seems to deny—to turn it from a schizophrenic structure that excludes change, messiness, surprise, and hence temporal experience into a flexible mechanism that produces history as a plurality of unpredictable stories and events, a conduit enabling us to touch upon the present in all its unaccountability and, in doing so, to reach out for ever new futures.

Well before Mondrian would elevate the grid's rationality to a myth of modern art, then, Moholy-Nagy rattled the cage of the grid's mythologies and prepared the ground for various postwar artists seeking to recharge modernist visions of order, control, purity, and transcendence with the productively untidy energies of time, change, chance, and history. Think, for instance, of Andy Warhol's *Twenty Blue Green Maos* of 1979 (p. 59), in which Warhol used his signature methods of gridded serialization in order to comment on the idolatry of modern politics, the ways in which the cult of political leadership undermine the possibility of transforming the present into a future different than the past. Think, even more so, of Robert Rauschenberg's 1989 *Coda* (p. 56), in which Rauschenberg placed depopulated images of time, passage, and the transitory within a rudimentary grid as if trying to document the extent to which the intransience of the modernist grid denies the hubbub of modern life in the name of geometric abstraction. In the work of Moholy-Nagy, as much as that of Rauschenberg, the grid is pushed toward or even across its own myth and logic. It opens itself to the vicissitudes of temporal flow, movement, embodiment, and history, and thus, in one way or another, anticipates what happens under the aegis of digital culture—namely, the grid's resurgence as a matrix, an informational pattern that permeates the material world and serves as the point of origin for virtually infinite and multidimensional permutations of one discrete source code.

II.

No doubt, we find ourselves at a point in time at which the reputation of matrices is rather low. We fear and loath them, consider them mechanisms of manipulation and deception, have contempt for them because they seem to repress what is human about humanity and turn our bodies into mindless slaves of omnipotent computers. "The Matrix is everywhere," Morpheus instructs Neo in the first installment of the Wachowski Brother's film *The Matrix* (1999). "It is all around us, even now, in this very room. You can see it when you look out your window or when you turn on your television. You can feel it when you go to work . . . when you go to church . . . when you pay your taxes. It is the world that has been pulled over your eyes to blind you from the truth."

Somewhat later, as he holds up a battery to the One destined to liberate humanity from the reign of the machines, Morpheus continues: "What is the Matrix? Control. The Matrix is a computer-generated dream world built to keep us under control in order to change a human being into this." Eager as ever to proliferate a certain technophobia with the help of the most advanced technologies of cinematic recording and editing, contemporary science fiction filmmaking has little good to say about matrices. They are seen as self-referential structures that enclose and embed human perception, that translate invisible codes into repressive, albeit illusory, architectures, that entertain our minds with deceptive simulations of pleasure, freedom, and self-determination while at the same time subjecting our bodies to the exigencies of uncontrolled abstraction. To live in a world in which informational patterns and digital systems largely structure the phenomenal world around us, for science fiction filmmakers such as the Wachowski Brothers, is to experience the present as a permanent extension of hell.

5. Peter Lunenfeld, "Introduction," in *The Digital Dialectic: New Essays on New Media* (Cambridge, MA: MIT Press, 1999), xv.

Digital systems, writes Peter Lunenfeld, "do not use continuously variable representational relationships. Instead they translate all input into binary structures of zeros and ones, which can then be stored, transferred, or manipulated at the level of numbers, or 'digits' (so called because etymologically, the word descends from the digits on our hands with which we count out those numbers)."[5] Unlike the analog, which relies on proportional relationships between original and mediated copy, on a certain sense of homology between message and signal, digital systems encode an image, a voice, or a text as series of zeros and ones and thus transmit input in a series of discrete steps rather than in a continuous stretch. While rudimentary forms of digitization preceded our age of computers—consider, for instance, the historical development of the Morse code in the mid-1830s, a method of distilling information into two basic types of signals that are easily produced and read by humans without the help of a computer—what constitutes the newness of digital culture as we have come to know it over the course of the past two decades or so is its stress on flux, malleability, inconclusiveness, and the unfinished. Digital photographs may exist in numerous versions on different users' hard drives. Because it doesn't take much to change

certain attributes of the pixels of a digital image, new renderings will inevitably emerge as time progresses, leaving us unable to pit the purity of an original against the putative mendacity of its copies. Precisely in that it breaks down the world into the most basic binary structures of zeros and ones, the digital opens a door to a new culture and aesthetic of potentially infinite variability, one in which the dimension of time liquefies notions of closure and formal stability.

Mathematicians define the matrix as a rectangular table of numbers or symbols that are used to describe linear equations. Yet matrices are not bound to two dimensions. Because one can add, subtract, multiply, or divide the data of a matrix in various ways, we can conceive of matrices accommodating three, four, or even more dimensions, in particular the dimension of time. Biologists, in turn, define the matrix as a specific material connecting plant or animal cells, a connective tissue that contains essential structures for the larger organization of the organism. Derived from the Latin "mater," the matrix is that which issues growth, development, and transformation—a model, a prototype, a code that may allow for endless copies and reproductions, but also for unpredictable combinations and networks of interaction. Though the matrix in both its mathematical and its biological sense operates with a limited set of discrete elements, it can enable technically finite but practically endless possibilities and actualizations, similar to the way in which the womb helps transmit basic information into a new organism, yet cannot determine this organism's every future move once it has left the womb's enclosure.

Neo, Trinity, and Morpheus, in the groundbreaking films of the Wachowski Brothers, rally against what they call the Matrix because it subjects the human body to informational patterns, manipulates people's sense perception, and hence undermines the principal possibility of human freedom and self-determination. Like Plato's cave, the Matrix entertains the human senses with false idols. It enslaves the mind because it translates digital code into deceptive perceptions and virtual realities; it directly feeds digital data into people's cerebral cortex so as to engulf their senses with illusionary worlds, histories, narratives, and material realities. One of the reasons, then, for the low repute of the matrix in contemporary popular culture has less to do with its

function of translating codes into multidimensional representations than with the fact that this act of translation is understood within the basic parameters of a Platonic separation of senses and soul, a Cartesian division of body and mind. Matrices, as we have come to think of them in the wake of the Wachowski Brothers' trilogy, are malicious because they short-circuit what is presented as the principal duality of human existence, namely the opposition of thought and matter; they need to be overturned because they fuse the spiritual and the sensual within womb-like spaces of complete predetermination. However innovative in its use of cinematography, special effects, and action choreography, the *Matrix* trilogy thus remains bound to conventional assumptions about the relationship between matter and mind. By mobilizing the modernist dialectic between presence and absence, the corporeal and the spiritual, all three films seek to warn us against computer-generated worlds that fool our eyes, numb our thoughts, and obfuscate the truth about our lack of freedom. It is, in the final analysis, by reinforcing the myth that digital codes and information turn totalitarian whenever they come to organize the structures of the visible world that the *Matrix* trilogy alerts us to the dangers of a future in which advanced technologies displace what is human about the human.

III.

The rise of digital culture is often seen as one whose successes rest on a profound division of body and mind, the messy realm of the physical and the disembodied world of codes and information. Cyberspace, so the argument goes, allows computer users to emancipate themselves from the strictures of time, place, and corporeality, to travel with the speed of light and the instantaneity of a mouse click while their bodies remain firmly planted in front of the screen. One of the achievements of the best of recent new media art is to call such suppositions—whether articulated with triumphant euphoria or apocalyptic gloom—radically into question. As it complicates mainstream understanding of the digital matrix—the patterns of codes that seem increasingly to structure the surface of our phenomenal world—this newer work draws our awareness not only to the ineluctable grounding of information in some material base, but also to the ways in which digital culture may situate

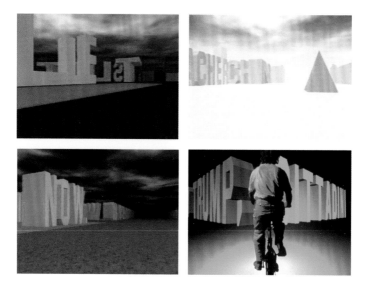

the user's body as an active element in the production of meaning. Rather than obliterating the physical and celebrating the cerebral, matrix art embraces the digital qualities of the unfinished and open-ended and highlights temporality and the embodied nature of human perception. Instead of mapping our world of technological mediation as one driven by a dialectic of presence and absence, the ephemeral and the eternal, matrix art explores tensions between the patterned and the random, among redundancy, noise, and information, to underscore the work and time it takes to see something as something in the first place, and to make sense of it.

If one function of the grid in classical modernism, then, was to sharpen our eye for the pure materiality of the canvas for the sake of transcending ordinary templates of time and space, the role of the matrix in new media art is to reveal the physical base of digital codes in order to intensify our bodily relation to time and space and foreground what is aleatory, inconclusive, and unpredictable about our process of perception. Mondrian's grids engage with the modernist obsession of "reading" the city in an effort to reduce the experience of metropolitan life to its most basic elements and find something spiritual and timeless amid the rhythms of modern existence. The perhaps most interesting works and installations of new media art, by contrast, whenever they

left
Jeffrey Shaw
The Legible City (details), 1988–91

overleaf
Julius Popp
Bit.Fall, 2006

engage with the idea of the matrix, situate viewers as active readers of computer-generated images and environments, the act of reading being understood as key to recognizing our present as a product and source of virtually endless possibilities and combinations and our perception thereof as being structured by indeterminacy, flux, and the vagaries of our corporeality.

Consider Jeffrey Shaw's pioneering installation *The Legible City* (pp. 28, 64), first developed between 1988 and 1991 and then re-issued in a somewhat recalibrated version under the name *The Distributed Legible City* in 1998. Shaw himself describes the initial installation as follows:

> In *The Legible City* *the visitor is able to ride a stationary bicycle through a simulated representation of a city that is constituted by computer-generated three-dimensional letters that form words and sentences along the sides of the streets. Using the ground plans of actual cities—Manhattan, Amsterdam, and Karlsruhe—the existing architecture of these cities is completely replaced by textual formations written and compiled by Dirk Groeneveld. Traveling through these cities of words is consequently a journey of reading; choosing the path one takes is a choice of texts as well as their spontaneous juxtapositions and conjunctions of meaning.* [6]

To be sure, because the texts guiding the user's path though the city—the Manhattan module, for example, gathers monologues by ex-Mayor Ed Koch, architect Frank Lloyd Wright, mogul Donald Trump, a tour guide, a trickster, an ambassador, and a taxi-driver—are predefined, the cyclist's creativity in producing legible text may be seen as rather limited. And yet, because reading here is directly coupled to physical activity—sudden turns of the wheel enable us to traverse and conjoin different narrations, and a slowing down or stepping up of our peddling speed has an immediate impact on the narrative's velocity—the user's encounter with textual material is far from merely passive or consumptive. On the contrary: Shaw's cities emerge as effects of our own physiological efforts, the manifestation of physical energy across a certain temporal stretch. Reading and

6. Jeffrey Shaw, *The Legible City*, http://www.jeffrey-shaw.net/html_main/frameset-works.php3 (cited August 18, 2006). The prototype for *The Legible City* was developed in 1988. The Manhattan version was produced in 1989; the Amsterdam version in 1990; and the Karlsruhe version in 1991. The later version, *The Distributed Legible City*, was adapted in 1998 as a network installation.

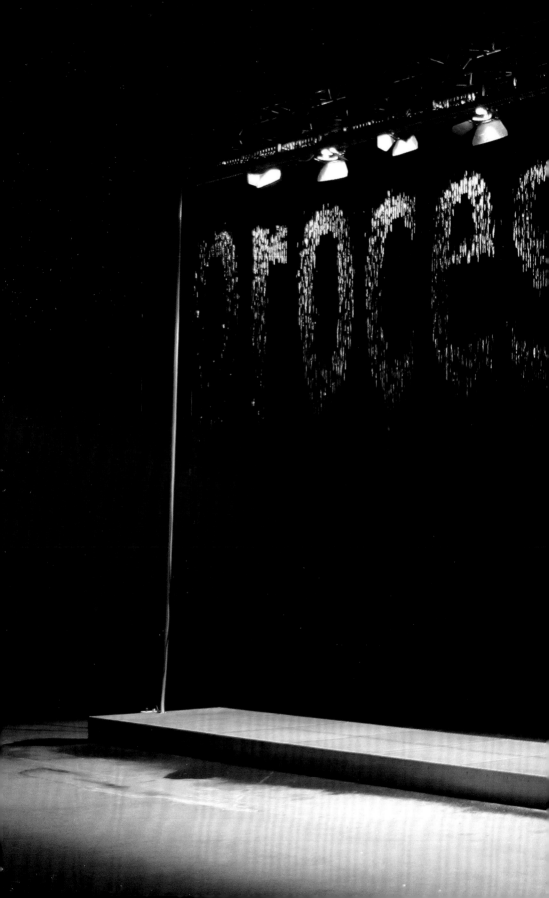

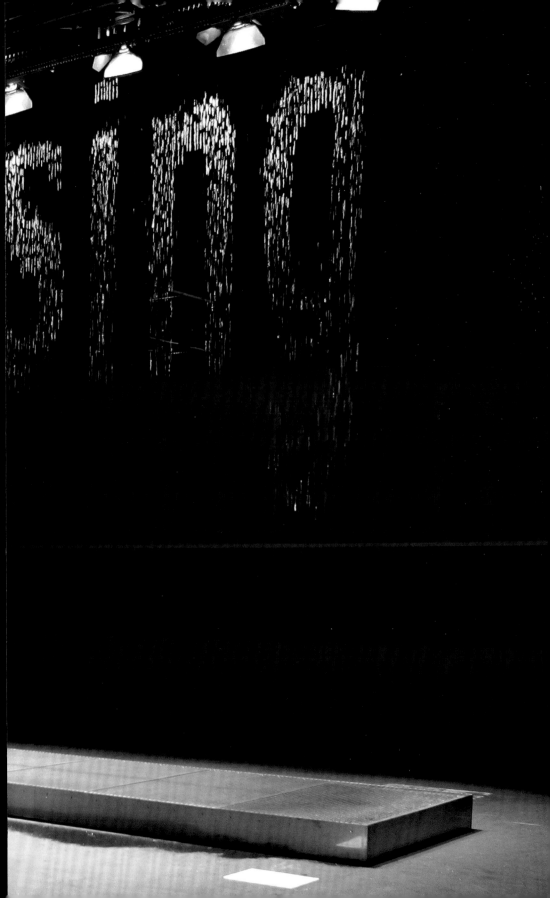

7. For more on the aesthetic implications of Shaw's work, see Mark B. N. Hansen, *New Philosophy for New Media* (Cambridge, MA: MIT Press, 2004), 47–92.

writing here go hand in hand. Both activities not only push common notions of reading and writing beyond the cerebral, but stress the topological features and temporal elasticity of texts in the age of digital culture, the way in which—think of the hypertext format of today's web pages—computerization changes the relationship between a text's verbal content and its visual form, emphasizes the material qualities of basic semantic units, and in so doing transforms our methods of reaching out for coherent meanings and pleasures. The rhythm and pace of our peddling thus not only situate us as writers and readers, they also create us as architects and urban planners of sorts. Each time we enter Shaw's virtual city and traverse its streets, the quirks of our bodies, moods, and desires produce completely different metropolitan representations. The computer may predefine the city's two-dimensional ground plan and grid, but in allowing our bodies to enter the dimensions of time and spatial volume, Shaw's installation redefines the city as a matrix: a grouping of data, information, and codes that permeates the material, that can be combined in virtually endless ways, and that engages the user in a curious dialectic of the patterned and the random. Rather than merely mapping or framing the real, Shaw's work brings into play a tactile production of spatial and temporal relations through physical mobility and mobilized perception. Computer-generated images have the power to absorb the viewer into the world they present, just as much as the viewer is enabled to immerse these images into his own body and sensuality. Whereas, in classical modernism, in however schizophrenic a form, the grid helped frame and hence control the frenzy of urban life within the bounded space of the canvas, Shaw's matrix situates us as viewers whose bodies themselves frame and reframe the visual field and whose senses thus remain open to experiences of flux, multiplicity, alterity, and indetermination.[7]

Consider also Julius Popp's installation *Bit.Fall* (2006, pp. 66–67). It consists of several hundred water jets that are hung high up in the air along a lateral construction. Magnetic vents enable each jet to emit individual water drops, thus producing not simply an artificial waterfall, but an extremely ephemeral recreation of a computer screen's bitmap, the grid and mechanism that organize discrete units

of information into meaningful representations. Popp's water jets are connected to and controlled by a computer that scans designated news web pages, identifies words or concepts used with a certain statistical frequency, and then "prints" these words by synchronizing the operation of all water vents in use. A series of words thus cascades down from the top of the installation, one quickly following the other, each needing but a few split seconds to become legible, each disintegrating before it hits the ground and makes way for the next, all of them forming an utterly disjunctive text that nevertheless represents the concerns, obsessions, conflicts, and trepidations of our fast-paced present. *Bit.Fall* is assembled in such a way that we can walk around its short-lived text, look at it from the front or behind, look through it at other viewers or works, and—on hot gallery days—entertain fantasies of jumping into it to cool down our bodies and information-hungry minds. In using the medium of water, Popp not only foregrounds the utter transience of what we consider news in our world of increasingly global and instantaneous connections, but also the inherent fluidity, the logic of flux, unfinish, and impermanence, that defines the core of the digital. To write, here, means to wrest instants of legibility—of information—from ongoing noise and meaningless streaming; to read is to track the process by which language briefly attains bodily form and to allow our minds to make imaginary connections between highly disjunctive elements. At first, Popp's vertical streams of horizontal words are reminiscent of the cataracts of green computer codes that, in the opening of *The Matrix*, eventually produce the film's credit information and stand for the sinister operations by which futuristic machines pull simulated worlds over people's eyes. But there is, of course, nothing sinister about Popp's *Bit.Fall*. In rendering visible the fluidity of meaning and representation in digital culture, in fragmenting the spectacle of news coverage today into some of its most basic elements, and in allowing the viewer to assume different positions in relation to the ephemeral appearance of text, Popp's matrix stresses the instability of sensory perception and the open-endedness of meaning. Unlike the data streams in *The Matrix*, which represent an attempt to turn history into preordained fate, Popp's falling bits draw our attention to process, chance, and the unpredictable—to new forms

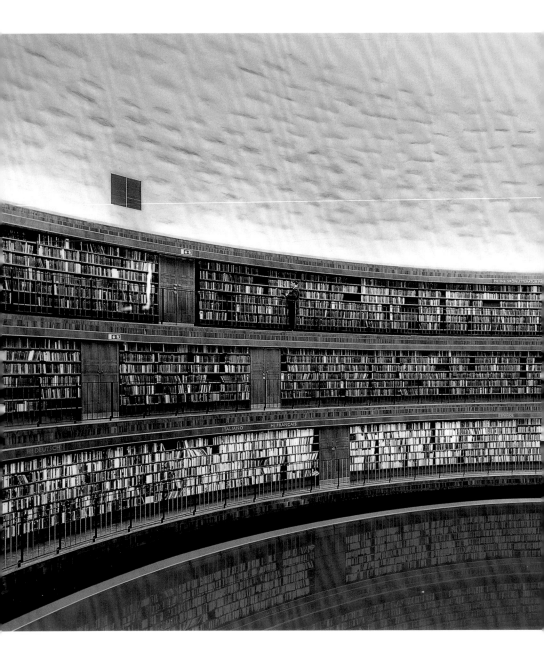

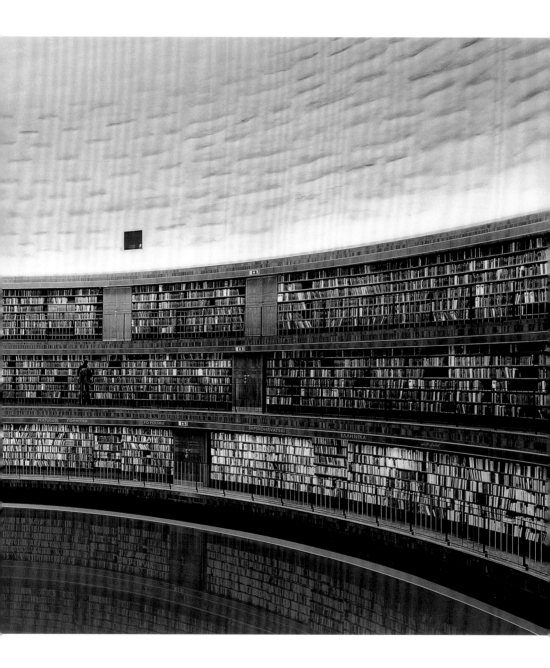

Andreas Gursky
Library, 1999

of reading and writing that are warranted by the reader's body, yet do not seek to contain this body and erase what is concrete, unique, and erratic about its existence in time.

Acts of reading and writing, then, in much of new media art, play a pivotal role in temporalizing the modernist grid, exploring the malleability of the digital matrix, and situating the spectator as an embodied user of aesthetic material. Unlike the classical reader, for whom the materiality of bodily experience is displaced by the noble realms of the spirit and the imagination, readers of new media art read with their entire bodies, their eyes operating as windows to the mind as much as they situate the subject physiologically within the shifting topography of the present and thus define this subject as a fluid, dispersed, and situational entity. It is important to note, however, that the emphasis of new media art on the temporality of reading and sensory perception even extends to work that—unlike the installations discussed above—is not time-based art. Think, for example, of digital photography, work that through the layering of different grids of pixels abandons the rationality of the grid, deserts classical photography's rhetoric of reference and indexicality, and instead approximates nothing other than the art of painting again. The monumental, obsessively composed work by Andreas Gursky, *Library* (1999, pp. 70–71), pictures a digitally manipulated view of the Stockholm public library, of a perfectly shaped hemisphere of bookshelves offering the trophies of humanistic learning to readers and viewers. In order to tighten the composition of his image, Gursky removed a set of escalators leading up to this level of the library as well as a phalanx of shelves normally visible in what is the lower portion of the picture. More importantly, however, Gursky replicated selected segments of bookshelves and inserted them into various other sections across the entire arc in order to achieve greater uniformity and visual integration. Gursky's seemingly cold objectivity here at first recalls the taxonomic realism of Bernd and Hilla Becher's industrial photography, but the longer we look at *Library* the more we tend to overcome any form of spectatorial distance. Instead of experiencing the work's monumentality as something overwhelming our senses and knocking us on the head, we find ourselves pacing up and down the work's enormous stretch, turning our eyes left and right

to compare certain sections with each other, trying to detect visual echoes and compositional rhymes, and searching for instances of minute misalignment and perspectival distortion. Though *Library*, at first sight, may convey a sense of timeless immobility and archetypical harmony, this picture turns the viewer into a detective-like reader whose first broad glance becomes one of close inspection of the entire image, tracking Gursky's dialectic of the patterned and the random. Though *Library*, at first, may produce impressions of utter closure and lofty transcendence, in actual fact it situates the viewer as one constantly reframing the picture through his or her own phenomenological activity, as one whose body and being in time produce unpredictable processes of reception and destabilize the modernist grid's grasp for disembodied spirituality and self-referential autonomy.

8. For more on the modular, see Lev Manovich, *The Language of New Media* (Cambridge, MA: MIT Press, 2001), 30–31.

Think also of Scott McFarland's series of equally monumental orchard images, all of them picturing the same basic garden landscape, yet each of them manipulating and varying individual elements to such a degree that purist horticulturists may think of these twenty-first century images as either visions of utopian possibility or nightmarish violations of natural integrity—or both at once. Whereas Gursky worked with strategies of visual abstraction in order to reduce the complexity of the visual world and explore its structural patterns and networks of intensity, McFarland's work is marked by operatic excess, a kind of visual overload and baroque plenitude that offers little on which to center or rest our gaze. The images' extreme widescreen format might recall pre-digital technologies of surround sight and virtualization such as the panorama, but McFarland's organization of lateral and orthogonal lines, of horizontal demarcations and vanishing points, undermines such a linkage and disallows any understanding of these images as flattened representations of a three-hundred-and-sixty degree perspective. Far from offering integrated views of plants, bushes, and gardens, McFarland's orchard images present nature as modular: a deliberate assembly of discontinuous elements that can be arranged and rearranged according to taste and mood.[8] Yet what is perhaps most striking about these images is how McFarland, within the frame of one and the same picture, juxtaposes plants that are in ostensibly different states of seasonal development.

73

Whatever we perceive as spatially disjunctive here primarily results from the co-presence of multiple times and temporal trajectories, a layering and conjoining of discrete seasonal moments that questions traditional notions of time as both linear and cyclical as much as it challenges conceptions of space as petrified and hence neutral in time. McFarland's digital orchards encourage viewers to become diligent readers of what appear to be but are in fact not images of unmitigated presence and natural plenitude. To read, here, means to sharpen one's attention for how digital mediation increasingly defines our present as an intersection of incommensurable rhythms, uncontained stories, and multiple durations. To read, here, is to move beyond the modernist grid's dialectic of absence and presence and instead open our eyes and senses to the dynamics of pattern and possibility, of dispersal and unpredictability, of unbounded space and heterogeneous time, which energize aesthetic experience in the age of the digital matrix.

Before the advent of computer-based editing and printing methods, print experts engraved letters into wooden or metal blocks so as to create prototypes for the production of principally unlimited copies. These were called matrices. Unlike the grid, the matrix is not a structure. It does not provide a self-enclosed system defining unequivocal positions for and relationships between individual elements. The matrix, instead, is a principle of generating and reproducing representations; it is the source from which the phenomenal world might ensue; it is the code that helps organize the real as a site of iteration and difference, pattern and randomness, noise and information. Where the grid maps operative relationships onto two dimensions and contains what is unpredictable within a seemingly timeless and unchangeable geometric structure, the matrix is unthinkable without the dimension of time, the way in which manifestations of a certain code or model evolve or devolve along a temporal trajectory. Matrix art, as discussed here, explores the extent to which the informational patterns that permeate our phenomenal world—our world of omnipresent computation and ubiquitous electronic screens—not only catalyze new experiences of flow, passage, and temporal openness, but also help remodel our physical existence, our forms of sensory perception, the way we produce proprioceptive

overleaf
Scott McFarland
*Orchard View with the Effects of Seasons
(Variation #1)*, detail, 2003–6

coherence (that is, how we define the boundaries of our bodies in relation to the world around us and its mushrooming technologies of electronic virtualization, prosthetic extension, mediation, and storage). In contrast to both the apocalyptic and the redemptive rhetoric of mainstream discourse, matrix art investigates digital culture and art as a springboard for new modes of aesthetic experience, aesthetics here being understood in its original sense as the process and pleasure of sensory perception. In the works and installations of Shaw, Popp, Gursky, and McFarland, the possibilities of digital reproduction neither emancipate the mind from the sluggish timetables of the body nor do they enslave the body by entertaining the mind with virtual versions of reality. Instead, the digital here allows us to experience and articulate a new interrelatedness of the cerebral and the sensory, of thought and perception—one that is categorically attuned to the trajectories of time and history, of becoming and dissipating.

"If you are killed in the Matrix," Neo asks Morpheus, "you die here?" To which Morpheus, prophetic and contemplative as ever, responds: "The body cannot live without the mind." New media art today, to the extent to which it invites us to become active and embodied readers (and writers) of digitally mediated perceptions, proves Morpheus's ruminations simultaneously right and wrong. Contemporary media artists might engage the matrix with the intention to reveal the interconnectedness of mind and body, but, as we have seen in the preceding pages, they do so less to repudiate the body's putative independence from the mind than to explore the mind's ineluctable coupling with the temporality of sensory perception—to pursue the fact that information cannot do without a material base and thought cannot thrive in isolation from the body's dynamic and, hence, unpredictable timetables.

LK

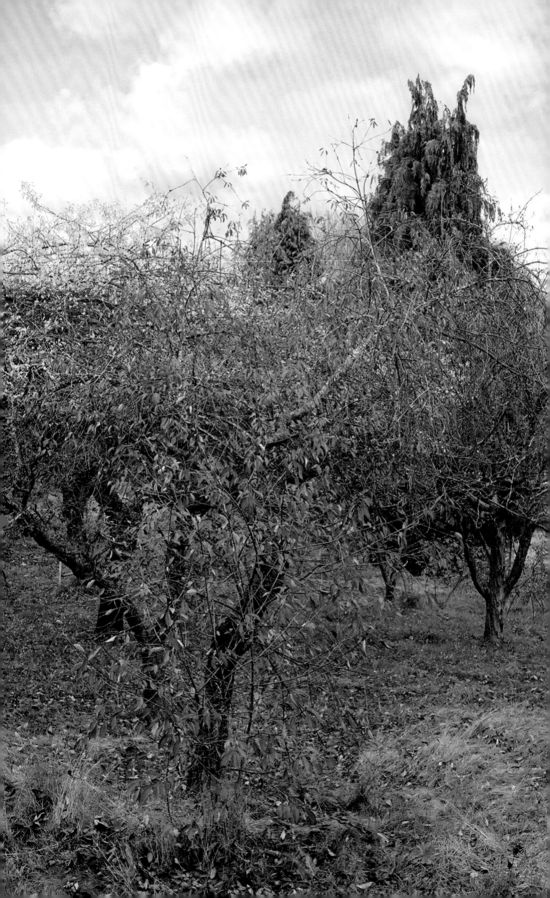

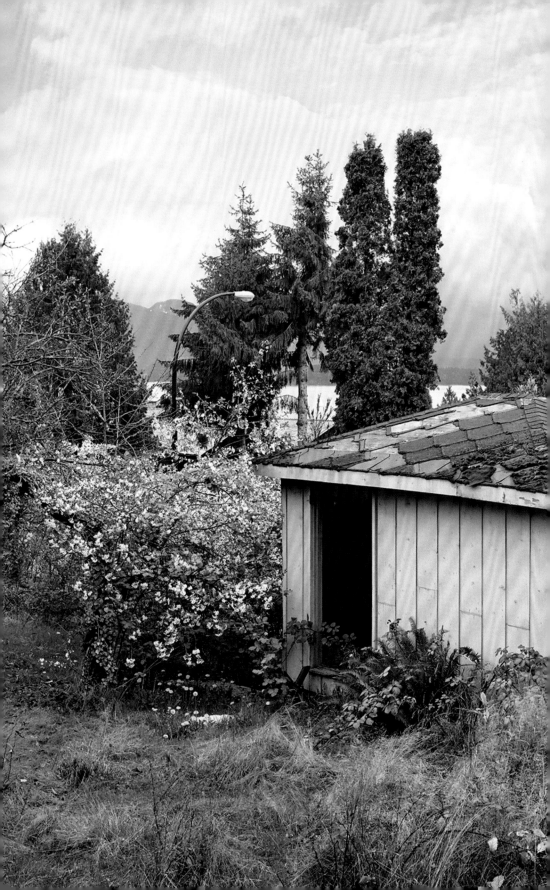

Dan Flavin
*Untitled (in honor of Leo at the 30th anniversary of
his gallery)*, 1987
Fluorescent light fixtures with red, pink, yellow,
blue, and green lamps
8-foot fixtures, 96 x 96 x 9 $^1/_4$" overall

Courtesy of the Panza Collection, gift to Fondo per
l'Ambiente Italiano, 1996, on permanent loan to the
Solomon R. Guggenheim Foundation, New York, L195.93
Photograph by David Heald © The Solomon R.
Guggenheim Foundation, New York
© 2006 Stephen Flavin / Artists Rights Society (ARS),
New York
Ill. cover, p. 24

Andreas Gursky
Library, 1999
Color coupler print, 1/6
62 $^3/_8$ x 126 $^1/_2$"

Collection of the Saint Louis Art Museum, funds given
by the Honorable and Mrs. Thomas F. Eagleton, 59:2000
© 2006 Andreas Gursky / Artists Rights Society (ARS),
New York / VG Bild-Kunst, Bonn, courtesy Matthew
Marks Gallery, New York and Monika Sprüth /
Philomene Magers, Cologne/Munich
Ill. pp. 70–71

Agnes Martin
Untitled #2, 1995
Acrylic and graphite on canvas
60 x 60"

Collection of Anabeth and John Weil, St. Louis
© 2006 Agnes Martin / Artists Rights Society (ARS),
New York
Ill. p. 20

Scott McFarland
*Orchard View with the Effects of Seasons
(Variation #1)*, 2003–6
Digital C-print, 1/3
40 x 120"

Courtesy of the artist and Regen Projects, Los Angeles
Ill. pp. 32–33, 76–77

Scott McFarland
*Orchard View with the Effects of Seasons
(Variation #2)*, 2003–6
Digital C-print, 1/3
40 x 120"

Courtesy of the artist and Regen Projects, Los Angeles
Ill. pp. 32–33

László Moholy-Nagy
Dynamik der Großstadt (Dynamic of the Metropolis), 1921–22
Film script, published in *Malerei, Photographie, Film (Painting, Photography, Film)*, Bauhaus Books series, vol. 8, 1925
Collection of the Washington University Art & Architecture Library, St. Louis
© 2006 Artists Rights Society (ARS), New York / VG Bild-Kunst, Bonn
Ill. pp. 46, 50–51

Piet Mondrian
Composition of Red and White, 1938–42
Oil on canvas
39 1/2 x 39 7/8"
Collection of the Saint Louis Art Museum, Friends Fund, 242:1972
Ill. p. 52

Carsten Nicolai
modular re.strukt, 2003
Installation of silkscreen prints
Dimensions variable
Courtesy of Galerie EIGEN + ART Leipzig/Berlin
© 2006 Artists Rights Society (ARS), New York / VG Bild-Kunst, Bonn
Ill. pp. 14, 16

Albert Oehlen
The Annihilator, 2001–6
Inkjet, oil, and lacquer on canvas
147 1/4 x 279 1/8"
Courtesy of Galerie Max Hetzler, Berlin
Ill. pp. 36–37

Julius Popp
Bit.Fall, 2006
Installation with water, pump, magnetic valves, and custom electronics
Dimensions variable
Courtesy of Galeries Jocelyn Wolff, Paris, & Nächst St. Stephan, Vienna
Photo by François Doury
Ill. back cover, pp. 66–67

Rashid Rana
A Day in the Life of Landscape, 2004
Digital print, ed. 5
72 x 113"
Courtesy of the artist and Bose Pacia, New York
Ill. pp. 40–41, 42

Robert Rauschenberg
Coda, 1989
Painting on aluminum
85 x 49"
Private collection, St. Louis, courtesy of Greenberg Van Doren Gallery
Art © Robert Rauschenberg/Licensed by VAGA, New York, NY
Ill. p. 56

Jeffrey Shaw
The Legible City, 1988–91
Interactive installation
Dimensions variable
Courtesy of the Zentrum für Kunst und Medientechnologie Karlsruhe
Ill. pp. 28, 64

John F. Simon, Jr.
Every Icon, 1996
Software, Macintosh G3 Powerbook, and plastic acrylic
Dimensions variable
Courtesy of the artist and Sandra Gering Gallery, New York
Ill. p. 10

Theo van Doesburg
Compositie VII: 'de drie Gratiën' (Composition VII: The Three Graces), 1917
Oil on canvas
33 1/2 x 33 1/2"
Mildred Lane Kemper Art Museum, Washington University in St. Louis, University purchase, Yeatman Fund, 1947
Ill. p. 18

Andy Warhol
Twenty Blue Green Maos, 1979
Acrylic and silkscreen on canvas
39 1/4 x 38"
Private collection, St. Louis, courtesy of Greenberg Van Doren Gallery
© 2006 Andy Warhol Foundation for the Visual Arts / Artists Rights Society (ARS), New York
Ill. p. 59

Lenders to the Exhibition

Bose Pacia, New York
Galerie EIGEN + ART, Leipzig/Berlin, Germany
Greenberg Van Doren Gallery, St. Louis
Solomon R. Guggenheim Foundation, New York
Galerie Max Hetzler, Berlin, Germany
Scott McFarland, Vancouver, Canada
Galerie Nächst St. Stephan, Vienna, Austria
Panza Collection, Milan, Italy
Julius Popp, Leipzig, Germany
Private collection, St. Louis

Rashid Rana, Lahore, Pakistan
Regen Projects, Los Angeles
Saint Louis Art Museum, St. Louis
John F. Simon, Jr., New York
Washington University Art & Architecture
Library, St. Louis
Anabeth and John Weil, St. Louis
Galerie Jocelyn Wolff, Paris, France
Zentrum für Kunst und Medientechnologie,
Karlsruhe, Germany

Contributors

Gwyneth Cliver is a Ph.D. candidate in the Department of Germanic Languages and Literatures at Washington University in St. Louis. In 2004 she received a DAAD fellowship to conduct research at the Georg-August-Universität Goettingen. She is currently writing a dissertation on the importance of modern mathematical theories in the novels of Robert Musil and Hermann Broch.

Sabine Eckmann is director and chief curator at the Mildred Lane Kemper Art Museum at Washington University in St. Louis where she also teaches in the department of Art History and Archeology. She is the author, co-editor, and co-curator of *Exil und Moderne* (2005), *Exiles + Emigrés: The Flight of European Artists from Hitler* (1997), which was awarded best exhibition catalog by the Association of International Critics of Art, and the author of *Collage und Assemblage als Neue Kunstgattungen Dadas* (1995). Current projects include the exhibition and catalog *Reality Bites: Making Avant-Garde Art in Post-Wall Germany*, which won the Emily Hall Tremaine exhibition award in 2005, and *Caught by Politics: Hitler Exiles and American Visual Culture* (forthcoming 2007), which she co-edited. Eckmann's research interests focus on 20th- and 21st-century European art and visual culture with a particular emphasis on the interrelation between aesthetic practices and social and political contexts. She has published and lectured on modern artists and their exilic practices, postwar German art, cold war aesthetics in German and American painting of the 1980s, participatory art forms of the 1990s, and new media and recent visualizations of trauma.

Patience Graybill is a Ph.D. candidate in Germanic Languages and Literatures at Washington University in St. Louis. In 2004 she received a Fulbright Fellowship to conduct research at the Freie Universität Berlin. She is currently writing her dissertation, which addresses the representation of archives, museums, and libraries in contemporary German literature and photography.

Lutz Koepnick is professor of German, Film and Media Studies at Washington University in St. Louis. He received his Ph.D. from Stanford University in 1994. He is the author of *The Dark Mirror: German Cinema between Hitler and Hollywood* (University of California Press, 2002), *Walter Benjamin and the Aesthetics of Power* (The University of Nebraska Press, 1999), and *Nothungs Modernität: Wagners Ring und die Poesie der Politik im neunzehnten Jahrhundert* (Wilhelm Fink Verlag, 1994). Koepnick is the 2002 recipient of the DAAD Prize for Distinguished Scholarship in the Humanities. His most recent book, *Framing Attention: Windows on Modern German Culture*, will be published by the Johns Hopkins University Press in 2007. He is also the co-editor of *Sound Matters: Essays on the Acoustics of German Culture* (Berghahn Books, 2004), *Caught by Politics: Hitler Exiles and American Visual Culture* (Palgrave Macmillan, forthcoming 2007), and *The Cosmopolitan Screen: German Cinema and the Global Imaginary, 1945 to the Present* (The University of Michigan Press, forthcoming 2007).